Design Science Collection

Series Editor

Arthur L. Loeb
Department of Visual and Environmental Studies
Carpenter Center for the Visual Arts
Harvard University

Amy C. Edmonson *A Fuller Explanation: The Synergetic Geometry of R. Buckminster Fuller*, 1987

Marjorie Senechal and George Fleck (Eds.) *Shaping Space: A Polyhedral Approach*, 1988

Judith Wechsler (Ed.) *On Aesthetics in Science*, 1988

Lois Swirnoff *Dimensional Color*, 1989

Arthur L. Loeb *Space Structures: Their Harmony and Counterpoint*, 1991

Arthur L. Loeb *Concepts and Images*, 1993

Hugo F. Verheyen *Symmetry Orbits*, 1996

Carl Bovill *Fractal Geometry in Architecture and Design*, 1996

Fractal Geometry in Architecture and Design

Carl Bovill

School of Architecture
University of Maryland

Springer Science+Business Media, LLC

Carl Bovill
School of Architecture
University of Maryland
College Park, MD 20742-1411

Library of Congress Cataloging-in-Publication Data

Bovill, Carl
 Fractal geometry in architecture and design / Carl Bovill.
 p. cm.
 Includes bibliographical references and index.
 ISBN 978-0-8176-3795-8 ISBN 978-1-4612-0843-3 (eBook)
 DOI 10.1007/978-1-4612-0843-3
 1. Architecture – Composition, proportion, etc. 2. Architectural
 design. 3. Fractals. I. Title
NA2760.B72 1996
729'.01'51474–dc20

Printed on acid-free paper.

ISBN 978-0-8176-3795-8

Designed and typeset by Merry Obrecht Sawdey, ShadeTree Designs, Minneapolis, MN, USA
Cover design by Joseph Sherman, Dutton and Sherman Design, Hamden, CT, USA.
Illustrations by Carl Twarog, Greenville, NC, USA.

9 8 7 6 5 4 3 2 1

Foreword

In a broad sense Design Science is the grammar of a language of images rather than of words. Modern communication techniques enable us to transmit and reconstitute images without needing to know a specific verbal sequence language such as the Morse code or Hungarian. International traffic signs use international image symbols which are not specific to any particular verbal language. An image language differs from a verbal one in that the latter uses a linear string of symbols, whereas the former is multi-dimensional.

Architectural renderings commonly show projections onto three mutually perpendicular planes, or consist of cross sections at different altitudes capable of being stacked and representing different floor plans. Such renderings make it difficult to imagine buildings comprising ramps and other features which disguise the separation between floors, and consequently limit the creative process of the architect. Analogously, we tend to analyze natural structures as if nature had used similar stacked renderings, rather than, for instance, a system of packed spheres, with the result that we fail to perceive the system of organization determining the form of such structures.

Perception is a complex process. Our senses record; they are analogous to audio or video devices. We cannot, however, claim that such devices perceive. Perception involves more than meets the eye: it involves processing and organization of recorded data. When we name an object, we actually name a concept: such words as *octahedron, collage, tessellation, dome,* each designate a wide variety of objects sharing certain characteristics. When we devise ways of

transforming an octahedron, or determine whether a given shape will tessellate the plane, we make use of these characteristics, which constitute the grammar of structure.

The Design Science Collection concerns itself with various aspects of this grammar. The basic parameters of structure such as symmetry, connectivity, stability, shape, color, size, recur throughout these volumes. Their interactions are complex; together they generate such concepts as Fuller's and Snelson's tensegrity, Lois Swirnoff's modulation of surface through color, self-reference in the work of M. C. Escher, or the synergetic stability of ganged unstable polyhedra. All these occupy some of the professionals concerned with the complexity of the space in which we live, and which we shape. The Design Science Collection is intended to inform a reasonably well educated but not highly specialized audience of these professional activities, and particularly to illustrate and to stimulate the interaction between the various disciplines involved in the exploration of our own three-dimensional, and, in some instances, more-dimensional spaces.

Carl Bovill's *Fractal Geometry in Architecture and Design* concerns itself in an articulate, systematic manner with the balance between the predictable and the surprise in art and design. Bovill points out that without the expected there can be no surprise. Without an understanding of symmetry there can be no appreciation of asymmetry. The distinction between order and disorder, between predictability and randomness has been called into question, however, by recent theories of *fuzzy logic, quasi-symmetry, chaos* and *fractals*. There appears to be structural order more subtle than that expressed by traditional symmetry, and patterns may be generated by orderly processes which are not on first analysis perceived to be orderly at all. Furthermore, the generating processes may incorporate a certain measure of chance.

Bovill initially presents a reader-friendly survey of Cantor sets, Koch ('snowflake') curves and the like, then demonstrates how nature may be imitated by the generation of such patterns. He demonstrates that with the use of such tools an architecture and urban design may develop which blends in with the natural environment. Analysis of creations by Frank Lloyd Wright, Piet Mondrian and LeCorbusier establishes a quantitative esthetic basis for the evaluation of designs, and for avoidance of deadly monotony.

Carl Bovill's compact volume effectively enriches our culture by introducing recent specialized concepts which are transforming the way we create and perceive our environment. He does so requiring a minimum of mathematical background, without sacrifice of rigor or depth.

Arthur L. Loeb
Cambridge, Massachusetts
December 1995

Fractal Geometry in
Architecture and Design

*Dedicated to
Mia, Anna, and Jean*

Contents

Preface

This book derives from an interest in fractal geometry that began when I read *Chaos* by James Gleick, which led me to *The Fractal Geometry of Nature* by Benoit Mandelbrot, and from there through many books on fractals and dynamic systems. I am especially indebted to *Chaos and Fractals* by Peitgen, Jurgens, and Saupe which lays out the mathematics of fractals and dynamic systems in an especially clear fashion. The intent of my book is to bring a conceptual and mathematical understanding of fractal geometry to the design community. Fractal awareness is eye-opening.

Many of the fractals discussed in this book were drawn with pen and tracing paper rather than with a computer. The iterations of the fractal drawings were produced by overlaying a new piece of tracing paper for each new iteration. Drawing by hand brings a tactile understanding of fractals. The reader is encouraged to draw a few fractals in order to obtain a firsthand experience in how a simple iterated rule can produce complex form. Some of the fractals, iterated function systems, Julia sets, and the Mandelbrot set require a computer to produce. The computer systems I used are listed in the text and references and are available at reasonable cost for PC and Macintosh personal computers.

I would like to thank a number of people for helping with this book. The faculty of the School of Architecture at the University of Tennessee and the faculty at the University of Maryland provided discussion and encouragement. The Academic Senate Research Committee at California Polytechnic

State University, San Luis Obispo, California provided a summer fellowship for me to prepare a proposal for the book for submission to publishers. Edwin Beschler and Alexis Kays at Birkhäuser helped me through the publishing process. I would also like to extend my appreciation to the text designer, Merry Obrecht Sawdey; the cover designer, Joseph Sherman; the illustrator, Carl Twarog; and the copyeditor, Wendy Lochner. Arthur Loeb reviewed the book and chose to include it as part of a series of books on design science. My wife, Jean, was the test reader of the text. She guided the book toward clarity. My daughters, Mia and Anna, drew fractals with a joy that encouraged me.

1 | Introduction

Symmetry

S ymmetry has long been an important design tool in architecture and de-
sign. The simplest symmetry is bilateral symmetry in which one side of
a composition is a mirror image of the other. Symmetry develops into
rhythm when entities are replicated along a line or rotated around a point. It
is not surprising that symmetry has played such an important role in design.
Many designs in nature have bilateral symmetry, like the human body, and
rhythmic repetitions, like fingers. Even our mental constructs such as good
and evil, up and down, and in and out, are symmetrical. Designers, represent-
ing the world in their work, are naturally drawn to symmetry and rhythm.

FIGURE 1.1 • Traditional architectural symmetry and rhythm.

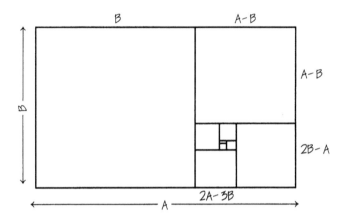

FIGURE 1.2 • The golden section creates a cascade of self-similar rectangles.

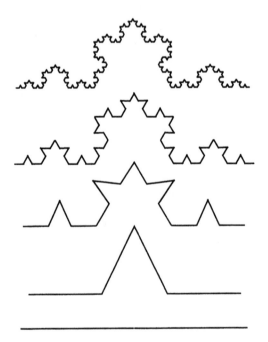

FIGURE 1.3 • The Koch curve generated through a few iterations.

Self-Similarity

There is symmetry in nature, but on closer observation there is also a complex diversity. Not all humans are the same size and shape. Oak trees are not identical. There is, however, a newly developed concept of symmetry that is proving very useful in describing nature's underlying diversity. This symmetry has invariance with respect to size. It has self-similarity, in which small parts of an object are similar to larger parts of the object, which in turn are similar to the whole object. Nature presents itself as a cascade of self-similar shapes, from trees to galaxies. The mathematical study of self-similar shapes and their relationship to natural shapes was first presented in *The Fractal Geometry of Nature* by Benoit Mandelbrot in 1977. One self-similar scale, the golden section, has long been a favorite proportioning device of architects. The golden section creates a self-similar spiral of rectangles. The cascade of self-similar proportions is what creates the magic. Our senses, having evolved in nature's self-similar cascade, appreciate self-similarity in designed objects.

Fractal Geometry

Fractal geometry is the study of mathematical shapes that display a cascade of never-ending, self-similar, meandering detail as one observes them more closely. The fractal dimension is a mathematical measure of the degree of meandering of the texture displayed. Natural shapes and rhythms, such as leaves, tree branching, mountain ridges, flood levels of a river, wave patterns, and nerve impulses, display this progression of self-similar form. Fractal concepts are being used in many fields from physics to musical composition. Architecture and design, concerned with the control of rhythm, can benefit from the use of this relatively new mathematical tool. The fractal dimension provides a quantifiable measure of the mixture of order and surprise in a rhythmic composition. Fractal geometry is a rare example of a technology that can reach into the core of design composition.

Michael Barnsley, in his book *Fractals Everywhere*, provides this warning in his introduction:

> Fractal geometry will make you see everything differently. There is danger in reading further. You risk the loss of your childhood vision of clouds, forests, galaxies, leaves, feathers, flowers, rocks, mountains, torrents of water, carpets, bricks, and much else besides. Never again will your interpretation of these things be quite the same.

Euclidean shapes do not display a cascade of textural depth. On closer observation, Euclidean shapes remain straight lines and smooth curves. The Koch curve is an example of a fractal. It is created in a recursive way, mapping

itself on to itself at smaller and smaller scales. It displays a cascade of self-similar structure.

Mathematician Benoit Mandelbrot describes Euclidean geometry in *The Fractal Geometry of Nature* in the following way:

> Why is geometry often called cold and dry? One reason lies in its inability to describe the shape of a cloud, a mountain, a coastline, or a tree. Clouds are not spheres, mountains are not cones, coastlines are not circles, and bark is not smooth, nor does lightning travel in a straight line.

Mandelbrot's fractal geometry has the capability of describing the cascade of detail observed in these natural forms. The relationship between nature and fractal geometry is often introduced through the example of the length of a coastline. As the length of the instrument one uses to measure a coastline gets smaller, the measured length of the coastline gets longer as smaller and smaller bays and inlets are included in the measurement. A natural rocky coastline displays a progression of detail similar to the Koch curve, except that its meandering is random.

The fractal dimension quantifies the cascade of detail. The Koch curve and a natural coastline, with their progression of detail, are more than one-dimensional lines and less than two-dimensional surfaces. They have a fractal dimension, a dimension that is greater than one and less than two. The Koch curve has a fractal dimension of 1.26. Many natural shapes, like the coastline of England, have fractal dimensions similar to the Koch curve.

Not only is nature's physical form fractal; the way nature changes through time is also fractal. Richard Voss in *The Science of Fractal Images* points out that

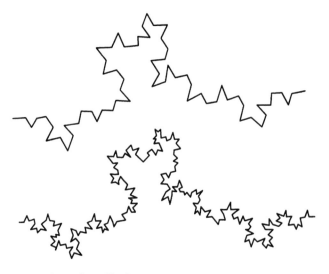

FIGURE 1.4 • A random Koch curve.

ocean flows, changes in the yearly flood levels of the Nile River, and voltages across nerve membranes display a fractal characteristic referred to as $1/f$ noise. He also points out that musical melodies display this same fractal characteristic. Martin Gardner, in an article in *Scientific American* on $1/f$ noise, summarizes the comparison with music in the following manner.

> It is commonplace in musical criticism to say that we enjoy music because it offers a mixture of order and surprise. How could it be otherwise? Surprise would not be surprise if there were not sufficient order for us to anticipate what is likely to come next. Good music, like a person's life or the pageant of history, is a wondrous mixture of expectation and unanticipated turns. There is nothing new about this insight, but what Voss has done is to suggest a mathematical measure for the mixture.

Architectural composition is concerned with the progression of interesting forms from the distant view of the facade to the intimate details. This progression is necessary to maintain interest. As one approaches and enters a building, there should always be another smaller-scale, interesting detail that expresses the overall intent of the composition. This is a fractal concept. Fractal geometry is the formal study of this progression of self-similar detail from large to small scales.

Broadly speaking, there are two ways that fractal concepts can be used in architecture and design. First, the fractal dimension of a design can be measured and used as a critical tool. As an example, the lack of textural progression

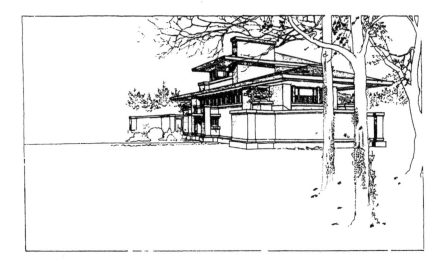

FIGURE 1.5 • Ferdinand Tomek House by Frank Lloyd Wright. FLLW Drawings are Copyright © 1995 The Frank Lloyd Wright Foundation.

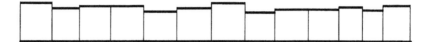

F I G U R E 1.6 • Fractal distribution of height and width for a row of townhouses.

could help explain why some modern architecture was never accepted by the general public. It is too flat. Second, fractal distributions can be used to generate complex rhythms for use in design. As an example, the fractal dimension of a mountain ridge behind an architectural project could be measured and used to guide the fractal rhythms of the project design. The project design and the site background would then have a similar rhythmic characteristic. In both criticism and design, fractal geometry provides a quantifiable calibration tool for the mixture of order and surprise.

Frank Lloyd Wright's houses provide a good example of the progression of detail from large to small. He often referred to the central idea that coordinated the design and this central idea often came from nature.

Row houses provide a simple example of how a fractal distribution can be used as a design tool. Figure 1.6 shows a layout of row houses in which both the heights and widths of each house have been varied according to a fractal distribution. The resulting variation captures the complex rhythms seen in natural forms and in indigenous buildings.

An understanding of fractal rhythms can open up an endless supply of design ideas for the architect or designer interested in expressing a more complex understanding of nature. Chapter 2 introduces the reader to some of the basic fractal constructions that first appeared at the turn of the century. Chapter 3 explains the mathematical definitions of fractal dimension from constructions such as the Koch curve to natural coastlines. Chapter 4 covers feedback and iteration. Iterated function systems open up a new way of generating images, and iteration of certain nonlinear equations produces the wonderfully complex Julia sets. Chapter 5 presents the concepts necessary to generate and understand random fractals. Chapter 6 covers the connection between musical rhythms and natural variation through time. Chapter 7 applies the fractal tools learned in the first five chapters to architectural and design criticism. Chapter 8 applies the fractal tools learned in the first five chapters to design method.

FIGURE 1.7 • The cascade of rectangles of the Hong Kong Peak International Competition winning entry by Zaha Hadid in 1982. Reproduced with permission from Zaha Hadid, Studio 9, 10 Bowling Green Lane, London EC1, England.

FIGURE 1.8 • A deep cascade of shape and texture is displayed in the wonderfully diverse residential designs of Lucien Kroll. Reproduced with permission from *The Architecture of Complexity*, Lucien Kroll, The MIT Press, 1986.

2 | Basic Fractals

The Cantor Set

Georg Cantor (1848–1914) was a German mathematician who worked on the foundations of set theory. He published the Cantor set in 1883. The Cantor set, along with the other fractals discussed in this chapter, are referred to as mathematical monsters by Mandelbrot because of their ambiguous features. The Cantor set is produced by starting with a unit interval $[0, 1]$ and taking out the center open interval $(1/3, 2/3)$. An open interval does not include the end points and is shown with rounded parenthesis. A closed interval includes the end points and is shown with squared parenthesis. This process leaves two closed intervals $[0, 1/3]$ and $[2/3, 1]$. The same procedure is repeated on each of these two intervals. This procedure is repeated an infinite number of times (Peitgen, Jurgens, and Saupe, 1992). The result is an infinite number of clustered points. Figure 2.1 shows the construction process for the Cantor set through a few of the infinite steps.

The Cantor set demonstrates very clearly two important features that relate fractal structures to natural structures. The first feature is self-similarity from the large scale to the small scale. As an example, the part of the Cantor set in the second stage of construction in the interval $[0, 1/3]$ is an exact copy of the whole Cantor set reduced by a scaling factor of $(1/3)$. Thus, any small part of the Cantor set can be seen as a scaled-down copy of the entire Cantor set. This feature of self-similarity also exists in nature. However, natural self-similarities do not extend to infinity and involve some random variations on

FIGURE 2.1 • The initial steps in the construction of the Cantor set. This image can be produced with tracing paper and pen. Each new iteration is drawn on a new sheet of tracing paper laid over the previous iteration.

a basic theme. The second important feature is the clustering of the points in the Cantor set. Natural systems from the stars in the night sky to a cauliflower display a clustering in their layout rather than an even or a strictly random distribution of features.

The Sierpinski Gasket

The Polish mathematician Waclaw Sierpinski (1882–1969) demonstrated another exceptional set in 1919. The Sierpinski gasket is produced in this manner: start with an equilateral triangle and take out a triangle in the center of

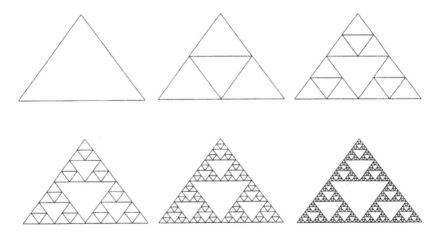

FIGURE 2.2 • A few of the steps in the construction of the Sierpinski gasket.

the initial triangle. The triangle to be removed is defined by the midpoints of the sides of the original triangle. The Sierpinski gasket is the set of points that remains after repeating this process on the remaining triangles an infinite number of times (Peitgen, Jurgens, and Saupe, 1992). Figure 2.2 shows the development of the Sierpinski gasket.

The Koch Curve

In 1904 Helge von Koch, a Swedish mathematician, introduced the Koch curve. The Koch curve was devised to demonstrate how to construct a continuous curve that was not smooth and thus not subject to the concept of tangent lines. The tangent concept is necessary for differentiation and calculus to be valid. The Koch curve was presented as a mathematical oddity, something that broke the rules.

The Koch curve is constructed by starting with a straight line. Divide the line into three segments. Remove the center segment. Replace the center segment with an equilateral triangle with the base removed. This process is repeated on a smaller scale on each of the four remaining straight-line segments. The process continues to infinity, resulting in a curve that contains no smooth sections. Figure 2.3 shows part of the construction of a Koch curve.

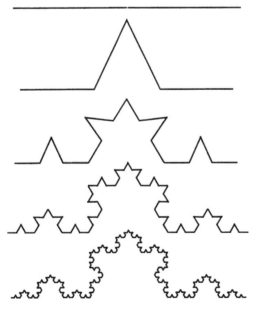

FIGURE 2.3 • Part of the construction of a Koch curve.

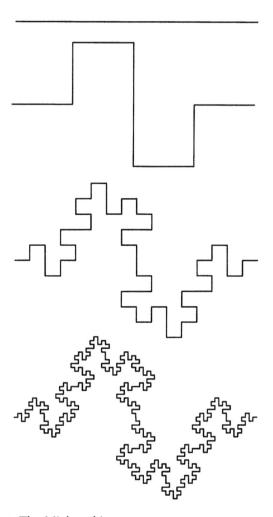

FIGURE 2.4 • The Minkowski curve.

Look at the first two steps in the generation of the Koch curve. The initiator is a straight line three segments long. The generator (the first stage into the construction) is four segments long. Since at each stage in the construction of the Koch curve the generator replaces all the straight-line segments in the curve, the length of the Koch curve continues to grow longer at each stage of construction. An infinite number of iterations produces an infinite length line. The length will be $(L \cdot (4/3)^n)$ where n is the number of steps of generation (Peitgen, Jurgens, and Saupe, 1992).

Figure 2.3 shows a Koch curve generated through four stages. The successive stages look somewhat similar, but they are not identical. The straight-line segments left in the curve become smaller and smaller as the curve develops through successive generation stages. The true Koch curve exists only in the

limit of infinite stages of generation where straight-line segments no longer exist in the curve. At the limit point of an infinite number of generation steps any part of the Koch curve would be strictly self-similar to the entire Koch curve. The intermediate stages of construction are an ever-improving approximation of the curve created after infinite construction stages. This is an important concept. Fractals in the mathematical sense only truly exist at the limit point of an infinite number of generation steps (Peitgen, Jurgens and, Saupe, 1992), but visually they have an approximate self-similarity throughout the generation steps. It is important to be aware of the purity of the mathematical idea, but the pure idea should not be used as a straight jacket to restrict the application of fractal concepts to design.

The Minkowski Curve

The initiator and generator of the Koch curve can be generalized to create a wide variety of meandering curves. Figure 2.4 shows the Minkowski curve drawn through a few stages of development. Note that the generator of the Minkowski curve replaces a straight-line segment that is four segments long with a curve that is eight segments long. The length of this curve grows faster from one stage of construction to the next than the Koch curve. The length will be $(L \cdot (8/4)^n)$ where n is the number of steps of generation.

The Peano Curve

Giuseppe Peano proposed his curve in 1890. It is constructed from a straight-line divided into three segments. The generator has nine segments, as shown in Figure 2.5. As in the previous curves the generator is used recursively to replace the straight-line segments in the curve through an infinite number of steps. In this curve each straight-line segment three units long is replaced by a curve that is nine units long. The length of this curve grows even faster than the Minkowski curve. The length will be $(L \cdot (9/3)^n)$ where n is the number of generations (Peitgen, Jurgens, and Saupe, 1992).

The Peano curve generated through an infinite number of steps provides a very strange result: it completely fills the plane. Euclidean geometry tells us that lines are one-dimensional and planes are two-dimensional. The Peano curve offers a paradox. It is a line, a one-dimensional entity, that is also somehow a plane, a two-dimensional entity.

Space-Filling Curves

The Koch, Minkowski, and Peano curves are all examples of curves that are more than one-dimensional. They represent a range from just beginning to fill the plane, the Koch curve, to completely filling the plane, the Peano curve.

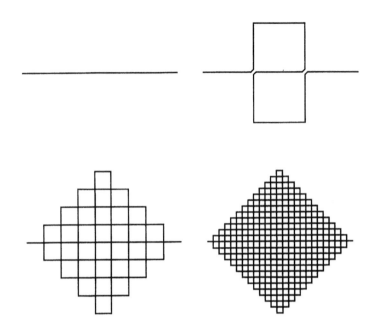

FIGURE 2.5 • The Peano curve.

The fractal dimension, which will be explained in the next chapter, is a measure of the extent to which a structure exceeds its base dimension to fill the next dimension. Figure 2.6 shows Koch, Minkowski, and Peano curves. Note the correspondence between the increasing fractal dimension and the increasing texture of the curve.

At first the idea of a curve that fills the plane seems strange. However, nature is full of examples of curves that must fill a plane or fill space to perform their function. A river and its tributaries need to drain a watershed area; they need to approach filling the plane of the watershed area in order to drain it. Another example is the blood distribution in your body. The distribution of blood through the arteries forms a vast tree structure in order to supply blood to the three dimensional form of your body. It is a space-filling curve. The veins also form a space-filling curve that returns blood from everywhere in your body back to your heart. (Mandelbrot, 1983).

Self-Similarity

In mathematics, terms such as self-similarity have very specific meanings. A structure is self-similar if it has undergone a transformation whereby the dimensions of the structure were all modified by the same scaling factor. The

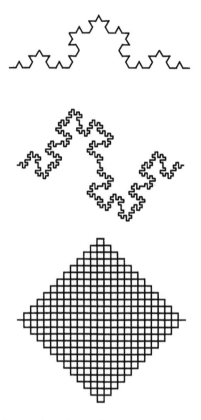

FIGURE 2.6 • Koch, Minkowski, and Peano curves. The Koch curve has a fractal dimension of 1.26; the Minkowski curve, 1.5; and the Peano curve, 2.0.

new shape may be smaller, larger, rotated, and/or translated, but its shape remains similar. "Similar" means that the relative proportions of the shapes' sides and internal angles remain the same. The reduction of a document on a copy machine is a similarity transformation. If a transformation reduces an object unequally in one or more dimensions, then the transformation is referred to as a self-affine transformation. In a self-affine transformation the internal angles of the shape and/or the relative proportions of the shape's sides might not remain the same.

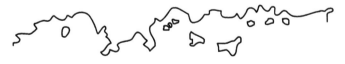

FIGURE 2.7 • The coastline at Sea Ranch, California.

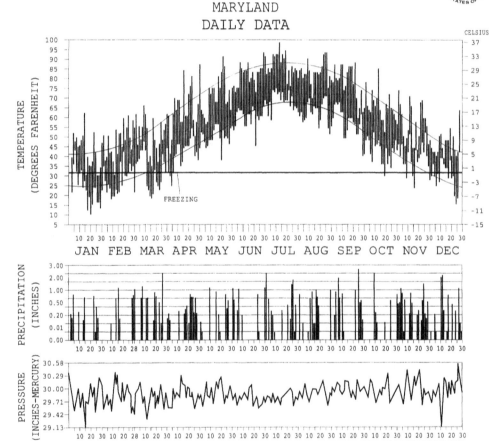

FIGURE 2.8 • Temperature variation for 1992 in Baltimore, Maryland. From the National Oceanic and Atmospheric Administration (NOAA).

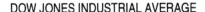

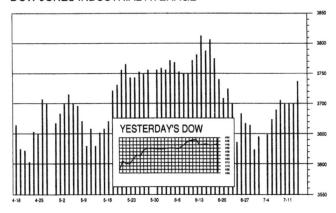

FIGURE 2.9 • The fluctuation of the stock market. From the *Washington Post*.

In nature there is an abundance of shapes that are statistically self-similar. A few examples are the large and small branching structure of a tree, the rocky inlets along a coastline, or weather fluctuations through time. Man–made entities can also display statistical self-similarity. The Dow Jones average is an example of statistical self-similarity. The hourly fluctuation through a day is similar to the daily fluctuations through a month and the monthly fluctuations through the years.

Fractal Geometry and Mathematics

Freeman Dyson relates the mathematics of fractal geometry to the history of mathematics in the following paragraph:

> Fractal is a word invented by Mandelbrot to bring together under one heading a large class of objects that have played an historical role in the development of pure mathematics. A great revolution of ideas separates the classical mathematics of the 19th century from the modern mathematics of the 20th century. Classical mathematics had its roots in the regular geometric structures of Euclid and the continuously evolving dynamics of Newton. Modern mathematics began with Cantor's set theory and Peano's space filling curve. Historically, the revolution was forced by the discovery of mathematical structures that did not fit the patterns of Euclid and Newton. These new structures were regarded as pathological, as a gallery of monsters, kin to the cubist painting and atonal music that were upsetting established standards of taste in the arts at about the same time. The mathematicians who created the monsters regarded them as important in showing that the world of pure mathematics contains a richness

of possibilities going far beyond the simple structures they saw in Nature. Twentieth century mathematics flowered in the belief it had transcended completely the limitations imposed by its natural origins.

Now, as Mandelbrot points out, Nature has played a joke on the mathematicians. The 19th century mathematicians may have been lacking in imagination, but Nature was not. The same pathological structures that the mathematicians invented to break loose from 19th century naturalism turn out to be inherent in familiar objects all around us.

This book is written for architects and designers. It is more important that designers have a visual and approximate understanding of what self-similarity is than that they memorize mathematical definitions. Once a person's eyes have been opened to the abundance of fractal self-similar structures in nature, a new awareness of form will arise.

Figure 2.10 shows one more fractal construction, known as the dragon curve. The fractal dimension of the interior of the curve is 2.0 while the fractal dimension of the perimeter of the curve is 1.52. Many shapes have different fractal dimensions depending on the point of view of the observer.

Further Study

Look through a copy of Sir Banister Fletcher's *A History of Architecture*. The illustrations show sections through buildings and building components. Figure 2.11 is one of these figures. Note the complex shapes with large and small scale indentations.

Draw a Koch curve using tracing paper. Each new iteration is drawn on a new sheet of tracing paper laid over the previous iteration. Try drawing a random Koch curve. A random curve is produced by letting a coin toss decide whether the blip being added to the curve goes up or down.

Draw a random Minkowski curve. Does this curve overlap itself?

The first eighty pages of Benoit Mandelbrot's *The Fractal Geometry of Nature* describe and illustrate many variations of generated fractal curves like the Koch, Minkowski, and Peano curves.

In Chapters 1 and 2 of *Fractals* by Hans Lauwerier, a connection is made between number systems and fractals. In one of the examples the Cantor set is related to the base three number system. These relationships can then be used to produce a computer code to generate fractals.

Look through architecture history books for cascading shapes. Figures 2.12 and 2.13 are examples of the cascade of shapes in architecture.

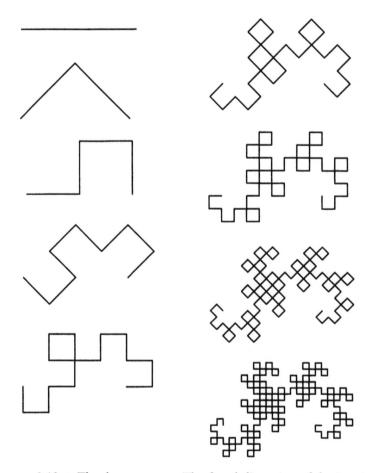

FIGURE 2.10 • The dragon curve. The fractal dimension of the interior of the dragon curve is 2.0. The fractal dimension of the perimeter is 1.52.

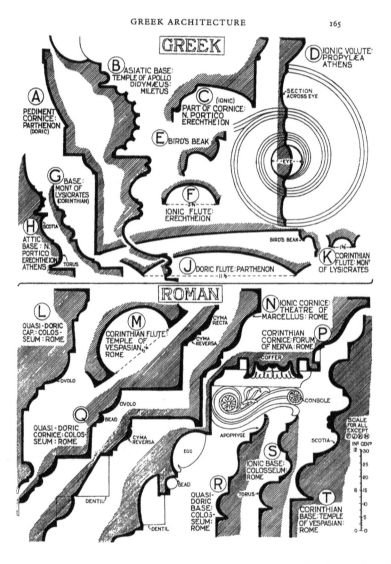

FIGURE 2.11 • Sections through Greek and Roman details. Reproduced with permission from The British Architectural Library, RIBA, London.

FIGURE 2.12 • A plan of the Wolfsburg Cultural Center by Alvar Aalto. Reproduced with permission from The Alvar Aalto Foundation, Helsinki, Finland.

FIGURE 2.13 • A diagram of a project for a biological research center at the University of Frankfurt by Peter Eisenman. Reproduced with permission from Eisenman Robertson Architects, 41 West 25th Street, New York, NY.

3 | The Fractal Dimension

Determining the Fractal Dimension

E ach stage of the generation process for a fractal curve adds more length to the curve. A fractal curve generated through an infinite number of steps will have infinite length. It was demonstrated in Chapter 2 that the length of different fractal curves grows from one generation stage to the next at different rates. The rate of growth of the length of the fractal curve is the distinguishing feature of the curve. The central concept is that length and the size of the instrument used to measure it are related. The relationship turns out to be a power law (Mandelbrot, 1983):

$$(y) \text{ is proportional to } (x)^d \qquad (3.1)$$

This law is also important to the definition of dimension. In mathematics there are many definitions of dimension in relation to a particular problem type. To understand fractal concepts, one needs to be familiar with three of these dimension definitions:

self-similarity dimension (D_s)

measured dimension (d)

box-counting dimension (D_b)

FIGURE 3.1 • Self-similar division of a line and a square.

All these dimensions are directly related to Mandelbrot's fractal dimension (D). For the purposes of the design concepts presented in this book the self-similarity dimension (D_s) and the box-counting dimension (D_b) are equivalent to Mandelbrot's fractal dimension (D). The measured dimension (d) is related to Mandelbrot's fractal dimension by the equation ($D = 1+d$). The discussion of these dimensions that follows is based on the explanations found in *Chaos and Fractals* (Peitgen, Jurgens, and Saupe).

Self-Similarity Dimension (D_s)

In Chapter 2 the concepts of self-similarity and scaling were introduced along with a collection of basic fractal curves. In all self-similar constructions there is a relationship between the scaling factor and the number of smaller pieces that the original construction is divided into. This is true for fractal and nonfractal structures. The relationship is the power law:

$$a = \frac{1}{(s)^D} = \left(\frac{1}{s}\right)^D \tag{3.2}$$

where (a) is the number of pieces and (s) is the reduction factor.

For nonfractal structures the exponent (D) is an integer. Figure 3.1 shows a line and a square divided into parts using a reduction factor of ($1/3$).

Solving for (D) in the power law $\left(a = 1/(s)^D\right)$ produces the following results (Peitgen, Jurgens, and Saupe, 1992):

$$\text{For the line:} \qquad 3 = \frac{1}{\left(\frac{1}{3}\right)^D} = 3^D \quad \text{thus } D = 1 \tag{3.3}$$

$$\text{For the square:} \qquad 9 = \frac{1}{\left(\frac{1}{3}\right)^D} = 3^D \quad \text{thus } D = 2 \tag{3.4}$$

FIGURE 3.2 • An Islamic garden motif.

Subdividing a structure into smaller similar parts does not produce a fractal if the number of parts is related to the scaling factor by an integer equal to the Euclidean dimension of the object. Qualitatively, the self-similar structures in Figure 3.1 are not fractal because there is no growth in length, area, or volume as one observes them more closely. These are subdivided Euclidean shapes. An architectural example is the Islamic garden design shown in Figure 3.2. The structure is self-similar but it is not fractal. However, compare the Islamic garden design with the Peano curve. An Islamic garden layout could be generated with a Peano curve. In addition, as will be demonstrated later in the book, methods for measuring the fractal dimension can be used on this type of figure to determine over what scale ranges the self-similarity is strongest.

The relationship between the number of pieces and the scaling factor for the Koch curve does not produce an integer exponent in the power-law relationship. In the Koch curve the scaling factor is $(1/3)$ and the number of pieces is (4):

$$4 = \frac{1}{\left(\frac{1}{3}\right)^D} = 3^D \tag{3.5}$$

Take the log of both sides of the equation.

$$\log(4) = (D)\log(3) \tag{3.6}$$

Solve for D:

$$D = \frac{\log(4)}{\log(3)} = 1.26 \tag{3.7}$$

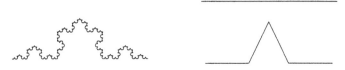

FIGURE 3.3 • The Cantor set and its generator. The self-similarity dimension is given by $D_s = \log(2)/\log(3) = 0.63$.

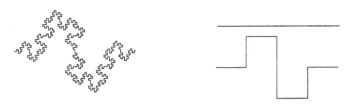

FIGURE 3.4 • The Koch curve and its generator. The self-similarity dimension is given by $D_s = \log(4)/\log(3) = 1.26$.

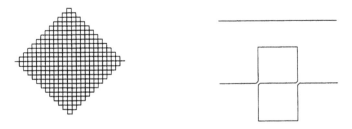

FIGURE 3.5 • The Minkowski curve and its generator. The self-similarity dimension is given by $D_s = \log(8)/\log(4) = 1.5$.

FIGURE 3.6 • The Peano curve and its generator. The self-similarity dimension is given by $D_s = \log(9)/\log(3) = 2.0$.

Generalizing this result, the self-similarity dimension is given by the power relation between the number of pieces and the reduction factor.

$$a = \frac{1}{(s)^D}$$

thus

$$D = \frac{\log(a)}{\log\left(\frac{1}{s}\right)} \tag{3.8}$$

where a = number of pieces and s = scaling factor.

Figures 3.3 through 3.6 show the calculation of the self-similarity dimension for some of the fractals presented in Chapter 2.

All the above fractal curves have infinite length at the limit when they are generated through an infinite number of steps. Thus, length cannot be used as a distinguishing characteristic. The fractal dimension, in this case given by the self-similarity dimension, provides a distinguishing characteristic. The fractal dimension is a measure of how quickly the curve approaches infinity. Visually, the fractal dimension is a measure of how much texture the line presents. Compare the Koch curve ($D = 1.26$) with the Minkowski curve ($D = 1.5$).

Measured Dimension (d)

Many natural shapes display a cascade of detail that is like the cascade of detail of the fractal curves presented in Chapter 2. Benoit Mandelbrot in his book *The Fractal Geometry of Nature* introduces the relationship between natural shapes and fractals through a discussion of how to determine the length of the coast of Britain. The coast of Britain is made up of many large, not so large, small, and even smaller bays and inlets. As one uses a smaller measuring device, more and more of the small inlets will be included in the measurement, and the resulting length of the coastline will become longer and longer. Figure 3.7 shows the length of the coast of Britain measured with straight-line segments set at 200 miles long, 100 miles long, 50 miles long, and 25 miles long.

As the straight-line segments get smaller, the polygon representation of the coast of Britain more nearly approaches the shape of the map. The length of the coastline increases as the measuring device becomes smaller. This is similar to the way in which the length of the fractals in Chapter 2 became longer and longer during each stage of construction. This increase in the measured length of a curve as the precision of the measurement device increases is what the fractal dimension measures.

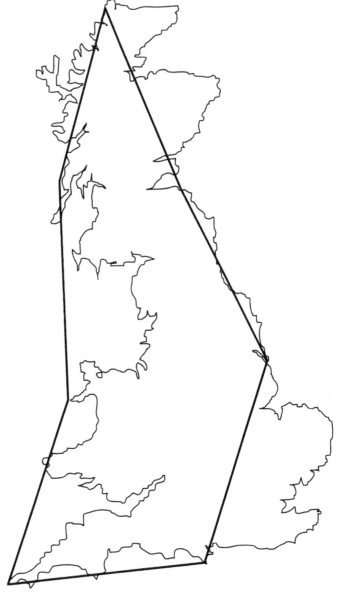

FIGURE 3.7(a) • Measuring the length of the coast of Britain with straight-line segments of 200 miles.

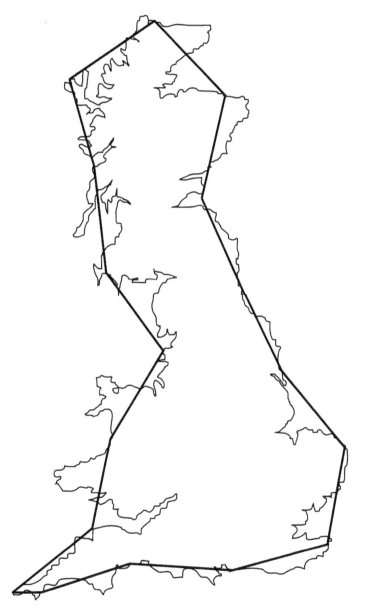

FIGURE 3.7(b) • Measuring the length of the coast of Britain with straight-line segments of 100 miles.

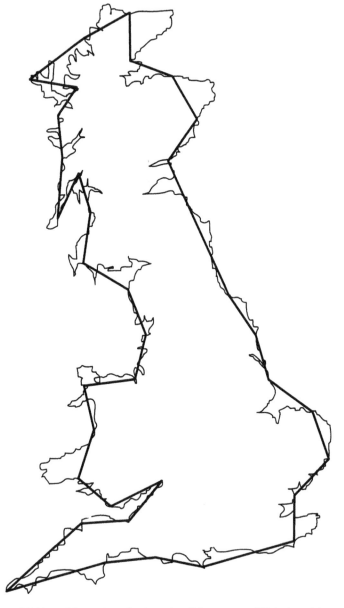

FIGURE 3.7(c) • Measuring the length of the coast of Britain with straight-
line segments of 50 miles.

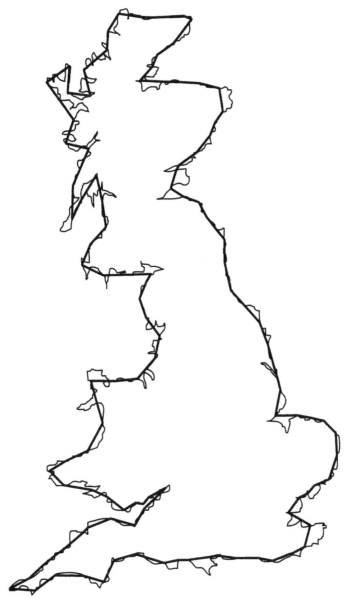

FIGURE 3.7(d) • Measuring the length of the coast of Britain with straight-line segments of 25 miles.

TABLE 3.1 • Measuring the Length of the Coast of Britain

number of units	unit length	coastal length
7	200 miles	1400 miles
16.25	100 miles	1625 miles
40	50 miles	2000 miles
96	25 miles	2400 miles

Mandelbrot discusses the problem of increasing coastline lengths in the following way:

> The result is most peculiar: coastline length turns out to be an elusive notion that slips between the fingers of one who wants to grasp it. All measurement methods ultimately lead to the conclusion that the typical coastline's length is very large and so ill determined that it is best considered infinite. Hence, if one wishes to compare different coastlines from the viewpoint of their extent, length is an inadequate concept.

For comparison with Euclidean shapes, the same measurement procedure is applied to a circle with a circumference approximately equal to the coast of Britain. Figure 3.8 shows how the length of an inscribed polygon's sides can

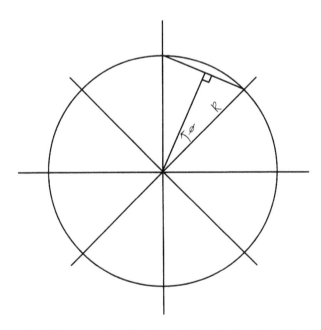

FIGURE 3.8 • The procedure for determining the length of the side of a polygon inscribed inside a circle.

TABLE 3.2 • Measuring the Circumference of a Circle

number of sides	side length	circumference
8	229.61 miles	1837 miles
16	117.05 miles	1873 miles
32	58.81 miles	1882 miles
64	29.44 miles	1884 miles

be calculated from the radius and the angle created by the construction of the polygon (Peitgen, Jurgens, and Saupe, 1992). The equation for the length of a side of the polygon is:

$$\text{polygon side length} = 2R \sin \theta \qquad (3.9)$$

where $\theta = (360)/(2)$(the number of polygon sides).

A circle with a radius of 300 miles has about the same circumference as the coast of Britain. The true circumference is $(3.14)(300) = 1884$.

Note that the length of the circle stabilized to a constant number. Smaller measuring devices do not result in longer and longer circumference measurements because there is not a cascade of bays and inlets as there is on the coast of Britain.

Numbers in a table are hard to understand. Displaying the numbers on a graph can often provide a clearer picture of any relationship between the numbers. Figure 3.9 shows a graph of the length of the coastline of Britain and the

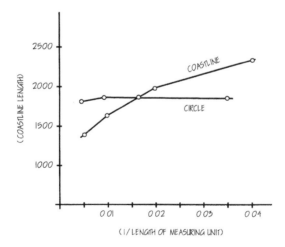

FIGURE 3.9 • Graph of the length of the coast of Britain and the circumference of a circle versus the precision of the measuring device used to make the measurement.

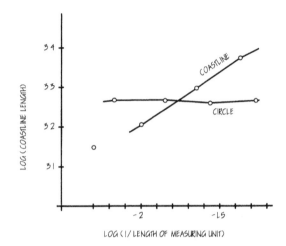

FIGURE 3.10 • Log-log graph of the length of the coast of Britain compared to the precision of the measuring unit used.

circumference of the circle, plotted on the Y-axis, compared to the precision of the measuring device used to make the measurement, plotted on the X-axis. The precision of the measuring device is (1/length of the measuring device). The graph for the circle produces a horizontal line. The graph for the coastline of Britain produces a line with an exponential shape.

To determine the nature of the exponential increase, it is useful to graph the log(the length of the coastline), compared to the log(the precision of the measuring unit). If a straight line can be fitted to the resulting set of points, the slope of the line will give the exponential rate of growth. Figure 3.10 shows this log-log graph of the coastline data.

On the log-log graph the points on the graph for the measurements done at 100 miles, 50 miles, and 25 miles line up in a very good straight line. The measurement done at 200 miles is so crude that it is best to drop it out of the calculation at this point. If the points do not line up, the best straight line can be determined through the method of least squares. The slope of the line in Figure 3.10 is calculated as follows. The slope of a line is defined as $(\Delta Y / \Delta X)$.

$$
\begin{aligned}
\text{Slope} &= \frac{\left[\log(2400) - \log(1625)\right]}{\left[\log\left(\frac{1}{25}\right) - \log\left(\frac{1}{100}\right)\right]} \\
&= \frac{(3.380 - 3.211)}{(-1.398 + 2.000)} \\
&= \frac{0.169}{0.602} \\
&= 0.281
\end{aligned}
$$

A straight line on a log–log graph has the following formula:

$$\log(u) = (d) \left[\log \left(\frac{1}{s} \right) \right] + (b) \tag{3.10}$$

where d = the slope of the line.

Equation 3.10 can be rewritten in power law form

$$u = (\text{constant}) \left(\frac{1}{s} \right)^d \tag{3.11}$$

For the coast of Britain, (d) is approximately equal to 0.28. Thus, the measured length (u) of the coast of Britain increases in proportion to $(1/s)$ raised to the power 0.28 where (s) is the length of the measuring unit.

The previous equation would suggest that the measured length tends to infinity as the length of the measuring unit approaches zero. Remember that the fractal curves in Chapter 2 had an infinite length after being generated through an infinite number of steps. In real shapes like the coast of Britain there are constraints on this progression to infinity. First, the precision of the map, picture, or drawing used is important to the process. The precision used in the calculation obviously cannot be greater than the precision of the map. Second, natural objects tend to have self-similar fractal characteristics, but this fractal characteristic does not extend to infinity. There is a range of size over which the self-similar fractal characteristics show up. Thus, there will be a range of values for the measuring instrument that makes sense in relation to the problem being investigated. For example, if the texture of a coastline in relation to a person on foot is the issue, the precision of the measurements should be smaller than if the texture of a coastline is to be measured in relation to a ship traveling up the coast.

Relationship Between the Self-Similarity Dimension (D_s) and the Measured Dimension (d)

If we determine the measured dimension of the Koch curve, we can compare it to its self-similarity dimension ($D_s = 1.26$), determined earlier in this chapter. The Koch curve has a reduction factor of $(1/3)$, so it makes sense to use straight-line segments that get smaller in powers of $(1/3)$ as measuring devices. The Koch curve is best measured with straight-line segments set at $(1, 1/3, 1/9,$ and $1/27)$ of the line segment length at the beginning of the construction process.

T A B L E 3.3 • Measuring the Length of the Koch Curve

stage	measuring unit length	number of units	total length
1	1/3	4	4/3 = 1.333
2	1/9	16	16/9 = 1.778
3	1/27	64	64/27 = 2.370

Displaying these results on a log-log graph of total length versus the precision of the measuring unit will produce a straight line. The log values are shown in Table 3.4.

The slope of the line can be calculated as we did earlier.

$$
\begin{aligned}
\text{Slope} &= \frac{\left[\log(1.778) - \log(1.333)\right]}{\left[\log(9) - \log(3)\right]} \\
&= \frac{(0.250 - 0.125)}{(0.954 - 0.477)} \\
&= \frac{0.169}{0.602} \\
&= 0.26
\end{aligned}
$$

The power law exponent for the growth of the length of the Koch curve related to the length of the measuring device is ($d = 0.26$). The self-similarity dimension for the Koch curve is ($D = 1.26$). This suggests that the relationship between the power law exponent and the self-similarity dimension is given by the following simple formula.

$$D = 1 + d \tag{3.12}$$

A derivation of this formula is fairly simple (Peitgen, Jurgens, and Saupe, 1992). Start with the power law relationship between the measured distance (u) and the length of the measuring device (s):

T A B L E 3.4 • Log-Log Calculations for the Koch Curve

$\log\left[1/ \text{(measuring unit length)}\right]$	$\log \text{(total length)}$
$\log\left[1/(1/3)\right] = \log(3) = 0.477$	$\log(1.333) = 0.125$
$\log\left[1/(1/9)\right] = \log(9) = 0.954$	$\log(1.778) = 0.250$
$\log\left[1/(1/27)\right] = \log(27) = 1.431$	$\log(2.370) = 0.375$

$$u = (\text{constant}) \left(\frac{1}{s}\right)^d \tag{3.13}$$

The constant relates to the Y-intercept of the plotted line on the log-log graph. We are only concerned with the slope of the line, so we can simplify the calculation by setting up units that result in the constant being equal to one. Thus the power law equation becomes:

$$u = \left(\frac{1}{s}\right)^d \tag{3.14}$$

Taking logarithms of both sides of the equation produces the log equation:

$$\log(u) = (d) \left[\log\left(\frac{1}{s}\right)\right] \tag{3.15}$$

The self-similarity dimension is defined by an equation between the number of straight-line pieces produced (a) when the scaling factor is (s):

$$a = \left(\frac{1}{s}\right)^D \tag{3.16}$$

Taking logarithms of both sides produces:

$$\log(a) = (D) \left[\log\left(\frac{1}{s}\right)\right] \tag{3.17}$$

The link between these two equations is the relationship between the measured length (u), the length of the measuring device (s), and the number of measurements required (a):

$$u = (a)(s) \tag{3.18}$$

Take the logarithm of both sides of the equation:

$$\log(u) = \log(a) + \log(s) \tag{3.19}$$

Now substitute Equation 3.15 for $\log(u)$ and Equation 3.17 for $\log(a)$ into Equation 3.19:

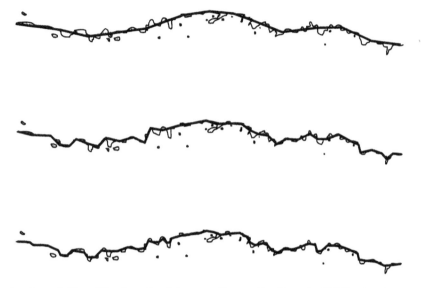

FIGURE 3.11 • The length of the coastline at Sea Ranch, California, determined by unit measuring devices that are 1600 feet, 800 feet, and 400 feet in length.

$$(d)\left[\log\left(\frac{1}{s}\right)\right] = (D)\left[\log\left(\frac{1}{s}\right)\right] + log(s) \qquad (3.20)$$

since $\log(1/s) = -\log(s)$:

$$-(d)\left[\log(s)\right] = -(D)\left[\log(s)\right] + \log(s) \qquad (3.21)$$

then dividing by $\log(s)$ produces:

$$-d = -D + 1 \qquad (3.22)$$

rearranging terms results in the relationship between the measured dimension (d) and the self-similarity dimension (D_s):

$$D_s = d + 1 \qquad (3.23)$$

The relationship between the self-similarity dimension and the measured dimension suggests another method of determining the fractal dimension of a

natural shape. If one graphs the number of straight-line measurements, the equivalent of (a) in the self-similarity dimension definition, compared to the precision of the measuring device ($1/s$) on a log-log plot, the slope of the line will yield an equivalent number to the self-similarity dimension (D_s). This is called the covering dimension.

To illustrate the use of the covering dimension, consider the coast of California at Sea Ranch. Figure 3.11 shows the coastline at Sea Ranch, California, measured with three different unit lengths appropriate to a yacht sailing up the coast. Figure 3.12 shows a magnified section of this same coast with unit lengths appropriate for a person walking along the cliff trail.

The fractal dimension is calculated below for the range of scale from 1600 feet to 800 feet. At 1600 feet, 15.5 units of measurement were needed; at 800 feet, 33 units of measurement:

$$
\begin{aligned}
D(1600 - 800) &= \frac{\left[\log(33) - \log(15.5)\right]}{\left[\log\left(\frac{1}{800}\right) - \log\left(\frac{1}{1600}\right)\right]} \\
&= \frac{\left[\log(33) - \log(15.5)\right]}{\left[-\log(800) + \log(1600)\right]} \\
&= \frac{\left[\log(33) - \log(15.5)\right]}{\left[\log(1600) - \log(800)\right]} \\
&= \frac{(1.519 - 1.190)}{(3.204 - 2.903)} \\
&= \frac{0.329}{0.301} \\
&= 1.093
\end{aligned}
$$

The fractal dimension is calculated below for the range of scale from 800 feet to 400 feet. At 800 feet, 33 units of measurement were needed; at 400 feet, 74 units of measurement:

$$
\begin{aligned}
D(800 - 400) &= \frac{\left[\log(74) - \log(33)\right]}{\left[\log(800) - \log(400)\right]} \\
&= \frac{(1.869 - 1.519)}{(2.903 - 2.602)} \\
&= \frac{0.350}{0.301} \\
&= 1.163
\end{aligned}
$$

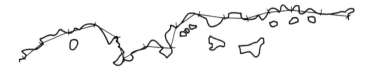

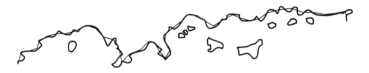

FIGURE 3.12 • The length of the coastline at Sea Ranch, California, determined by measuring devices that are 400 feet and 200 feet in length.

The fractal dimension is calculated below for the range of scale from 400 feet to 200 feet. At 400 feet, 15 units of measurement were needed; at 200 feet, 36 units of measurement:

$$D(400 - 200) = \frac{\left[\log(36) - \log(15)\right]}{\left[\log(400) - \log(200)\right]}$$
$$= \frac{(1.556 - 1.176)}{(2.602 - 2.301)}$$
$$= \frac{0.380}{0.301}$$
$$= 1.262$$

Figures 3.11 and 3.12 and the fractal calculations that accompany them illustrate the importance of choosing the right range of scale for the problem. For a person navigating a yacht up the coast, staying a good distance offshore for safety, the coastline is very smooth. There are very few large points to go around on the northern California coast. However, to a person walking along the Sea Ranch coast trail, which runs right along the edge of the rocky shoreline, the coastline is a complex set of rocky points and inlets mixed with small beaches. The texture the walker sees is very different from the texture the boat captain sees.

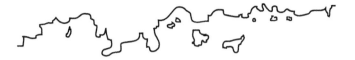

FIGURE 3.13 • The coastline at Sea Ranch, California.

Box-Counting Dimension (D_b)

If one is presented with the problem of determining the fractal dimension of a complex two-dimensional image, the three previous methods do not work well. There generally is not a clearly repeating self-similar structure, as in the Koch curve, so the self-similarity dimension method will not work. There is usually no curve like a coastline where one can use the measured dimension or the covering dimension. Figure 3.13 shows the coastline at Sea Ranch, Cal-

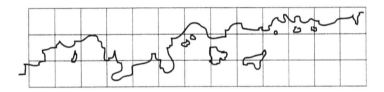

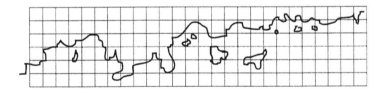

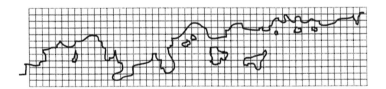

FIGURE 3.14 • Three box-counting grids placed over the coastline of California at Sea Ranch, including the small islands. The larger grid is 400 feet per unit of grid. The next is 200 feet per unit of grid. The smallest is 100 feet per unit of grid.

ifornia, again. There are numerous small, rocky islands along the coast. The previous methods of calculating fractal dimension could not include the islands in the procedure.

The box-counting dimension is a systematic extension of the measured and covering dimensions. It is produced in the following manner. Superimpose a grid of square boxes over the image in question. The grid size is given as (s). Count the number of boxes that contain some of the image. This will result in a number of boxes $N(s)$. Repeat this procedure, changing (s) to smaller and smaller grid sizes, and count the resulting number of boxes that contain the image $N(s)$. As in the measured and covering dimensions, the next step is to plot $\log[N(s)]$ versus $\log(1/s)$ on a log-log diagram. The slope of the straight line that best represents the data is an estimate of the box-counting dimension (D_b). The slope of the line (D_b) is given by the following formula:

$$D_b = \frac{\left[\log\left(N(s_2)\right) - \log\left(N(s_1)\right)\right]}{\left[\log\left(\frac{1}{s_2}\right) - \log\left(\frac{1}{s_1}\right)\right]} \tag{3.24}$$

where $(1/s)$ = the number of boxes across the bottom of the grid.

The fractal dimension is calculated below for the range of scale from 400 feet to 200 feet. At 400 feet there were 26 boxes with coastline or island running through them; at 200 feet, 65 boxes:

$$
\begin{aligned}
D(400 - 200) &= \frac{\left[\log(65) - \log(26)\right]}{\left[\log(26) - \log(13)\right]} \\
&= \frac{(1.813 - 1.415)}{(1.415 - 1.114)} \\
&= \frac{0.398}{0.301} \\
&= 1.322
\end{aligned}
$$

At 200 feet there were 65 boxes with coastline or island running through them; at 100 feet, 164 boxes:

$$
\begin{aligned}
D(200 - 100) &= \frac{\left[\log(164) - \log(65)\right]}{\left[\log(52) - \log(26)\right]} \\
&= \frac{(2.215 - 1.813)}{(1.716 - 1.415)} \\
&= \frac{0.402}{0.301} \\
&= 1.336
\end{aligned}
$$

Including the rocky islands in the calculation increased the fractal dimension from 1.26 to 1.32.

Cautions

It should be pointed out that if a self-similar curve is defined in a way that produces overlapping parts, the self-similarity dimension (D_s) will be greater than any of the empirically measured dimensions. This happens because the experimentally measured dimensions (d and D_b) have no knowledge of the overlapping parts of the curve. The self-similarity dimension (D_s), which is based on the definition of the curve, will take into account the potential for overlapping.

When using experimentally measured dimensions it is important to report which method was used and over which range of scales the procedure was calculated. The Sea Ranch coast is an example. In the 1600 foot to 400 foot scale range, the coastline is not very fractal ($D = 1.1$). In the 400 foot to 200 foot scale range, the coastline presents a more fractal appearance ($D = 1.26$). When the box-counting method was used and the rocky islands were included in the calculation, the fractal dimension for the 400 foot to 200 foot scale range increased to ($D = 1.36$).

The box-counting dimension method applied to a design such as the Islamic garden layout, which is not mathematically a fractal, will produce a non-integer dimension for a certain range of box sizes. At smaller box sizes the box-counting dimension will drop off to 1.0. This is an indication that over a certain range of scale there is a self-similar characteristic to the design, but after closer examination one only sees lots of straight lines. Even though this type of analysis is outside the realm of true fractals, it is useful design information to know the range of scale over which self-similarity is present.

Further Study

Figure 3.15 is an elevation of Alvar Aalto's home and second office. Cut out a square opening in a piece of paper. The opening should be the size of the part of the facade in the middle where there are no windows. Move this around the elevation noting that a fairly complex set of lines shows through the opening in the paper. Now cut the dimension of the opening in the piece of paper in half both vertically and horizontally. Again scan around the image noting the complexity of what you observe. Keep reducing the scale of the opening by one half until the scan through the opening mainly displays straight lines. You have qualitatively spanned the fractal range of this elevation. For this exercise ignore the siding.

Using the box-counting method, measure the fractal dimension of a solid rectangle. The grid of boxes should be placed so it fits right on top of the solid rectangle. A second grid at half the size of the first grid will produce a box count of four times as many boxes. What box-counting dimension will this produce?

Using the box-counting method, measure the fractal dimension of a single straight line. Align the boxes with the straight line. A second grid at half the

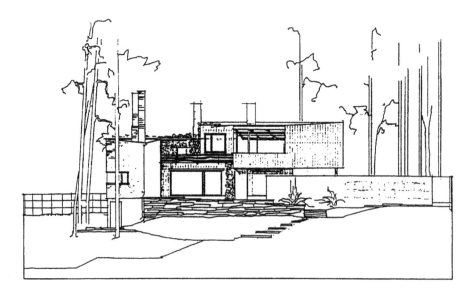

FIGURE 3.15 • An elevation of Aalto's home and office. Reproduced with permission from The Alvar Aalto Foundation, Helsinki, Finland.

size of the first grid will produce a box count of two times as many boxes. What box-counting dimension will this produce?

The coast of England displayed a cascade from large bays down to small inlets. Traditional architecture also displays this cascade of large and small detail. Note the large and small scale undulations of the interior walls of the church shown in Figure 3.16, and of the sections through doorways shown in Figure 3.17. Calculate the fractal dimension of one or two of the doorway sections.

Chaos and Fractals by Peitgen, Jurgens, and Saupe provides a very clear development of the mathematics of fractal geometry. The derivations presented in this chapter are based on the derivations in *Chaos and Fractals*. If you find your interest in fractals growing, *Chaos and Fractals* is an excellent book to study.

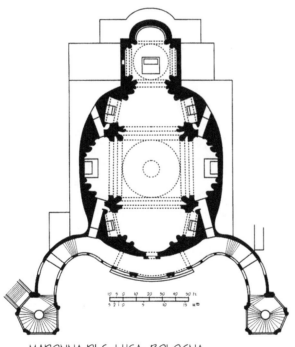

MADONNA DI S. LUCA: BOLOGNA
BY DOTTI

FIGURE 3.16 • Plan of the church of Madonna Di S. Luca in Bologna. Reproduced with permission from The British Architectural Library, RIBA, London.

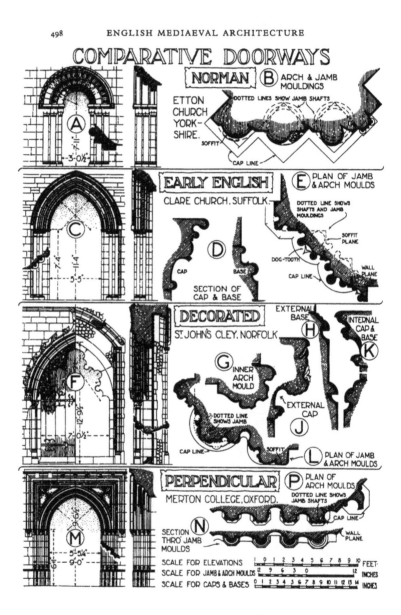

FIGURE 3.17 • A series of sections cut through Romanesque doorways. Reproduced with permission from The British Architectural Library, RIBA, London.

4 | Feedback and Iteration

Iterated Function Systems

I n Chapters 2 and 3 various classic fractals were discussed, and Mandelbrot's idea of fractal dimension was explained. The concept of fractal dimension was extended to cover natural forms such as coastlines. It is easy to see a connection between the natural form of a coastline and a random Koch curve. However, there is also a mathematical connection between the classic fractals and natural forms (Peitgen, Jurgens, and Saupe, 1992).

Iterated function systems (IFS) provide the connection. Peitgen, Jurgens, and Saupe in *Chaos and Fractals* use an analogy of a copy machine with multiple reducing lenses to describe what these systems do. Imagine a copy machine with three lenses. Each lens reduces the original image by $(1/2)$, and the three reduced images are placed on top of the original image in the form of an equilateral triangle. Figure 4.1 shows this process generated through a few stages with a square and a circle as the initial figures. The result is a form with the characteristics of the Sierpinski gasket.

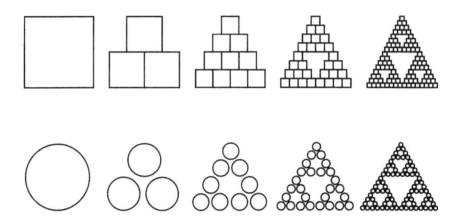

FIGURE 4.1 • An IFS starting with a square and a circle.

The configuration of the reducing lenses determines the form of the resulting figure; the initial image is not important. The final image is called the attractor of the system, and mathematical theory shows that as long as the lenses reduce the image, there is only one attractor per IFS setup (Peitgen, Jurgens, and Saupe, 1992).

Designers have long been aware that the process used to develop a design for a sculpture, painting, advertisement campaign, or building has a large effect on the end result produced. IFS theory reinforces this concept.

Changing the configuration and reducing characteristics of the lens system will produce a different image. Figure 4.2 shows the result of a different

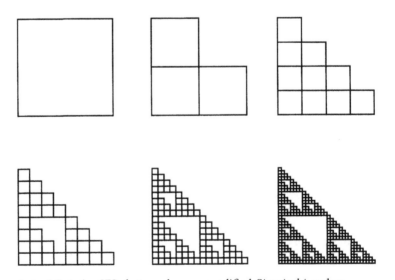

FIGURE 4.2 • An IFS that produces a modified Sierpinski gasket.

placement of the three (1/2) reduced images that produced the Sierpinski gasket in Figure 4.1. The result is a modified Sierpinski gasket (Peitgen, Jurgens, and Saupe, 1992).

The analogy of the reducing lenses represents mathematical transformations of figures on a two-dimensional plane that reduce the figures in size. IFS theory allows reductions in size that maintain mathematical similarity as well as reductions that modify similarity. An example of a reduction or contraction transformation that does not preserve similarity is one that scales by a different factor in the X and Y directions. IFS theory also allows shear, rotation, and reflection of the initial image as part of the contraction. In mathematics these are referred to as affine linear transformations. Affine means that the reduced figure is not similar in the formal mathematical sense of the word. Angles are not preserved, and all sides of the reduced figure are not similar in relative size to all sides of the starting figure.

The Sierpinski gasket is only one example of the images that an IFS can produce. The possibilities are endless. Figure 4.3 shows an IFS that starts with

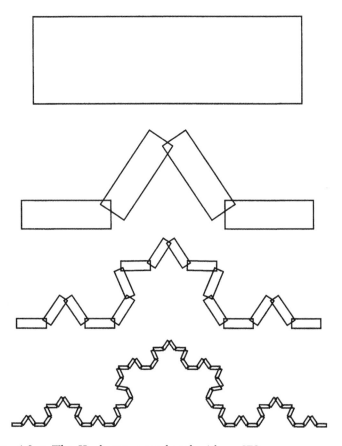

FIGURE 4.3 • The Koch curve produced with an IFS.

a rectangle and replaces the original image with four rectangles that have been reduced by (1/3) in both the X and the Y direction placing them as shown on the figure. The result is the Koch curve.

Natural looking shapes can also be produced with IFS. A system with four contractions, as shown in the first stage of Figure 4.4, will produce a fern like image. One of the contractions reduces the original rectangle to a line that will eventually become the stem of the fern.

Figures 4.1, 4.2, 4.3, and 4.4 can be drawn by hand using tracing paper overlays to produce each stage of the IFS process. It is helpful to produce some figures by hand to obtain a solid understanding of how an IFS operates. However, the transformations rapidly become too difficult to reproduce accurately by hand. The fern in Figure 4.4 demonstrates the accuracy problem. In each stage of the iteration the transformation is not quite accurate, eventually result-

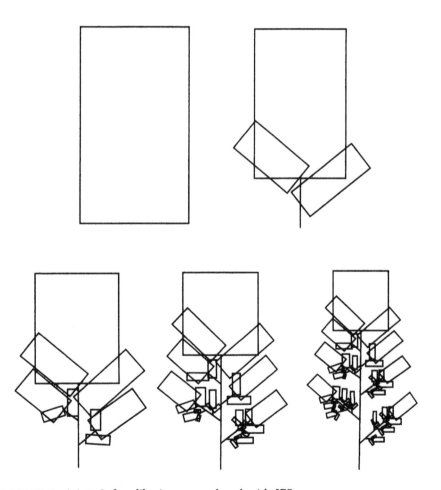

FIGURE 4.4 • A fern like image produced with IFS.

ing in extreme inaccuracy. A computer is necessary to explore the images that can be produced with IFS theory. Figure 4.5 shows some computer generated IFS attractors.

Figure 4.6 shows the fern that mathematician Michael Barnsley produced as part of his work with IFS theory. Barnsley's fern demonstrated that natural forms could be generated with the same type of mathematical transformations that produce the Sierpinski gasket and the Koch curve. The importance of this is described very well in *Chaos and Fractals* by Peitgen, Jurgens, and Saupe:

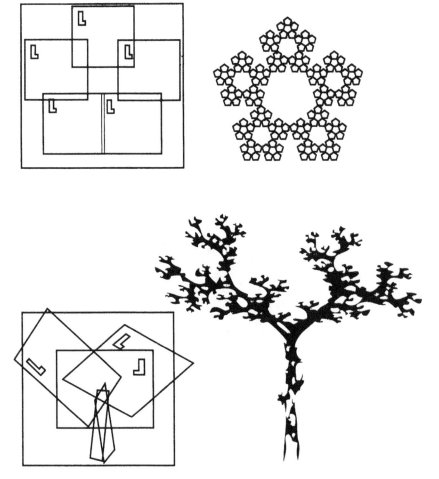

FIGURE 4.5 • Computer generated IFS attractors. Reproduced with permission from *Chaos and Fractals;* Peitgen, Jurgens, and Saupe; Springer-Verlag; 1992.

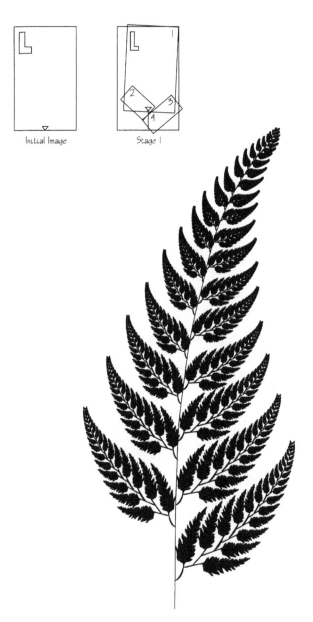

Initial Image

Stage 1

FIGURE 4.6 • Barnsley's fern. Reproduced with permission from *Chaos and Fractals;* Peitgen, Jurgens, and Saupe; Springer–Verlag; 1992.

The importance of Barnsley's fern to the development of the subject is that his image looks like a natural fern, but lies in the same mathematical category of construction as the gasket, the Koch curve, and the Cantor set. In other words, that category not only contains extreme mathematical monsters which seem very distant from nature, but it also includes structures which are related to natural formations and which are obtained by only slight modifications of the monsters. In a sense, the fern is obtained by shaking an MRCM (multiple reduction copy machine) which generated the Koch curve so that the lens systems alter their positions and contraction factors.

This transition from a Koch curve into Barnsley's fern is illustrated in Figure 4.7.

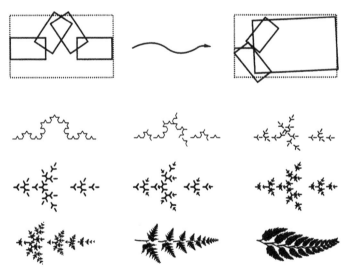

FIGURE 4.7 • The Koch curve transformed into a fern by modifying the four transformations of the IFS. Reproduced with permission from *Chaos and Fractals*; Peitgen, Jurgens, and Saupe; Springer-Verlag; 1992.

Mathematics of Affine Transformations

For a transformation that moves a point along a line the equation is:

$$X(n + 1) = AX(n) + B \tag{4.1}$$

For example, if $X(0) = 2$, the transformation with $A = -1$ and $B = 0$ would place $X(1)$ at -2 on the X-axis. Applying this transformation again will place $X(2)$ at $+2$ on the X-axis. This transformation will oscillate between these points.

If $A = -1/2$ and $B = 1$, then the transformation is a contraction transformation and will produce the following sequence of points

$$X(0) = +2$$
$$X(1) = -1 + 1 = 0$$
$$X(2) = 0 + 1 = 1$$
$$X(3) = -\frac{1}{2} + 1 = \frac{1}{2} = 0.50$$
$$X(4) = -\frac{1}{4} + 1 = \frac{3}{4} = 0.75$$
$$X(5) = -\frac{3}{8} + 1 = \frac{5}{8} = 0.625$$
$$X(6) = -\frac{5}{16} + 1 = \frac{11}{16} = 0.688$$
$$X(7) = -\frac{11}{32} + 1 = \frac{21}{32} = 0.656$$
$$X(8) = -\frac{21}{64} + 1 = \frac{43}{64} = 0.672$$

This transformation is slowly approaching a fixed point, an attractor in the language of IFS.

For a transformation that moves a point around on a plane, there are two equations, since there are two coordinates for any point on the plane.

$$X(n + 1) = AX(n) + BY(n) + E \tag{4.2}$$
$$Y(n + 1) = CX(n) + DY(n) + F \tag{4.3}$$

For an IFS the transformations must be contractions. A contraction mapping with the above equations is achieved if A, B, C, and D are all in the range

bounded by -1 and $+1$. Thus, an IFS that produces a specific picture can be specified with six numbers (A, B, C, D, E, and F) per contraction transformation used (Peitgen, Jurgens, and Saupe, 1992). An IFS uses more than one contraction transformation.

There is another form of the equations shown above. It is the result of the following polar transformation:

$$R = \sqrt{A^2 + C^2} \qquad (4.4)$$

$$\theta = \arccos\left(\frac{A}{\sqrt{A^2 + C^2}}\right) \qquad (4.5)$$

$$S = \sqrt{B^2 + D^2} \qquad (4.6)$$

$$\beta = \arccos\left(\frac{B}{\sqrt{B^2 + D^2}}\right) \qquad (4.7)$$

The new set of equations becomes:

$$X(n+1) = (R\cos\theta)X(n) - (S\sin\beta)Y(n) + E \qquad (4.8)$$

$$Y(n+1) = (R\sin\theta)X(n) + (S\cos\beta)Y(n) + F \qquad (4.9)$$

The six parameters that define the transformation are now two scaling factors R and S, two rotations θ and β, and two translations E and F. The Barnsley fern shown in Figure 4.6 can be described by four transformations of the initial rectangle. The rotation angles are given in degrees.

Thus, the complex image of Barnsley's fern can be reduced to 24 numbers. This specific image can then be transmitted to another IFS on another computer, where it can be reproduced (Peitgen, Jurgens, and Saupe, 1992).

TABLE 4.1 • The Four Equations for the Barnsley Fern.

	translations		rotations		scalings	
	E	F	θ	β	R	S
1	0.0	1.6	-2.5	-2.5	0.85	0.85
2	0.0	1.6	49	49	0.3	0.34
3	0.0	0.44	120	-50	0.3	0.37
4	0.0	0.0	0	0	0.0	0.16

The Chaos Game

Iterated function system (IFS) images can be generated more efficiently through the use of a random process. This random process is called random iterated function systems (RIFS). To understand what the process does, it is helpful to play a chaos game (Barnsley, 1988). The chaos game is played by drawing a triangle as shown in Figure 4.8 and labeling the vertices A, B, and C. Select a point anywhere inside or outside the triangle. Use a die defining 1 and 2 as A, 3 and 4 as B, and 5 and 6 as C so that each throw produces a random choice of the vertices of the triangle. Measure half the distance from the arbitrary point to the vertex of the triangle chosen at random by the die and mark a new point. Continue the game from the new point.

Instead of a random collection of points, the result of this chaos game, after many iterations of the game, is the Sierpinski gasket. Figure 4.9 shows a chaos game construction of the gasket.

The reason the chaos game described above produces the Sierpinski gasket is that the rules that were set up for the game are equivalent to the affine transformations that produced the Sierpinski gasket with an IFS. The difference is that in the IFS all three transformations work at once to reduce the original square by $(1/2)$ and then to translate the reduced squares to the appropriate place. In the chaos game the transformation happens one point and one transformation at a time. The transformation is chosen at random so that the entire figure will eventually be drawn. To get a better understanding of the process, set up the triangle again. This time start the chaos game at the upper apex of the triangle and label the points as they are placed. Since the game starts at a point that belongs to the final attractor, the Sierpinski gasket,

FIGURE 4.8 • The setup triangle for the chaos game.

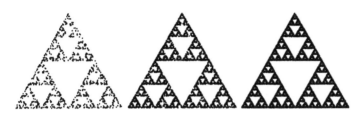

FIGURE 4.9 • The result of the chaos game described above.

the process and the resulting image are a little easier to follow. This play of the chaos game is shown in Figure 4.10. The game started at vertex A. The first four random throws of the die were B, C, B, B (Peitgen, Jurgens, and Saupe, 1992).

The RIFS example discussed here produced a Sierpinski gasket. However, any set of affine transformations that will produce an IFS image can also be implemented as a RIFS. In the random method dots pop onto the

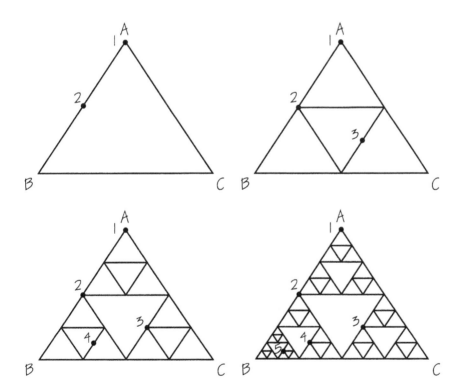

FIGURE 4.10 • Playing the chaos game starting at the upper apex of the triangle.

computer screen in a random fashion but once past the first few points they appear only on what will eventually become the resultant image of the RIFS.

There are a number of available computer programs and computer codes described in books that can open up IFS image generation to anyone who wants to explore it. Two IFS programs are listed below. The first is a Macintosh program. The second can be purchased in Mac or PC versions.

Fractal Attraction
Kevin Lee and Yosef Cohen
Academic Press, 1992

The Desktop Fractal Design System
Michael Barnsley
Academic Press, 1992

Both systems allow the user to graphically create, position, rotate, shear, and rescale rectangles onto the initial rectangle. Each new rectangle produces an additional affine transformation for the IFS. The following images were produced with the *Desktop Fractal Design System*. In this system, as the user places and modifies rectangles, the image begins to form, so there is immediate feedback about the quality of the final image that will be produced. In Figures 4.11 and 4.12, the rectangles that defined the images were left overlaid on the image. The rectangles can be turned off once a desirable image has been discovered. This process is a form of image research that the design community should take advantage of.

F I G U R E 4.11 • An image generated with RIFS using *The Desktop Fractal Design System.*

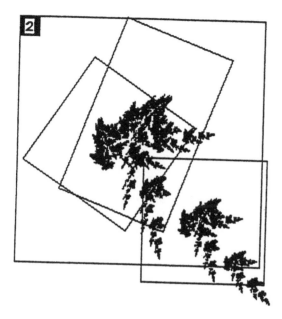

FIGURE 4.12 • An image generated with RIFS using *The Desktop Fractal Design System*.

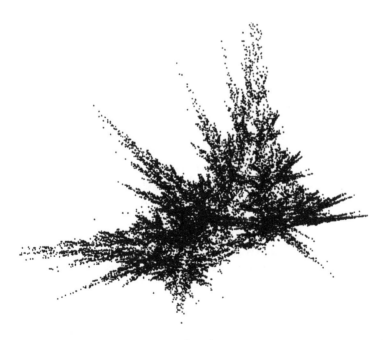

FIGURE 4.13 • An image generated with RIFS using *The Desktop Fractal Design System*. This image was produced by the author's nine year old daughter, Anna.

Complex Numbers

The next branch of fractal geometry to be discussed is Julia sets. The quadratic family of Julia sets is the result of the iteration of the equation:

$$Z(n + 1) = Z(n)^2 + C \qquad (4.10)$$

where Z and C are complex numbers.

Thus, it is necessary to have some understanding of complex numbers.

Complex numbers provide a solution to algebraic equations that would otherwise not have solutions because there is no way to define the meaning of $(\sqrt{-1})$. No number multiplied by itself will produce the product (-1). Because of this, equations like

$$X^2 + 1 = 0 \qquad (4.11)$$

had no solution. This problem was circumvented by the creation of imaginary numbers with the property:

$$i^2 = -1 \qquad (4.12)$$

A complex number has a real part and an imaginary part.

$$Z = X + Yi \qquad (4.13)$$

Z is a complex number. X is the real part of the complex number. Y is the imaginary part of the complex number. Real numbers can be ordered along a line. In other words, one real number is larger or smaller than another real number. Complex numbers cannot be ordered along a line. Because there are two components to complex numbers a two-dimensional plane is necessary to order the complex numbers (Peitgen, Jurgens, and Saupe, 1992). Convention makes the X-axis the real axis and the Y-axis the imaginary axis.

Addition and multiplication of complex numbers are performed as follows:

$$Z + W = (X + Yi) + (U + Vi) = (X + U) + (Y + V)i \qquad (4.14)$$
$$Z \cdot W = (X + Yi) \cdot (U + Vi) = XU + XVi + YUi + YVi^2 \quad (4.15)$$

since $i^2 = -1$, $YVi^2 = -YV$

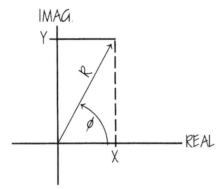

FIGURE 4.14 • The complex plane.

$$Z \cdot W = (X + Yi) \cdot (U + Vi) = (XU - YV) + (XV + YU)i \quad (4.16)$$

Complex numbers can also be expressed as polar coordinates that cover the two-dimensional complex plane. The transformation to polar coordinates is done in the following manner:

$$R = \sqrt{(X^2 + Y^2)} \quad\quad (4.17)$$

where R is the modulus of the complex number.

$$\sin \theta = Y/R \quad\quad \text{and} \quad\quad \cos \theta = X/R \quad\quad (4.18)$$

where θ is the argument of the complex number.

With polar coordinates the multiplication of two complex numbers is easier to achieve:

$$Z = R(\cos \theta + i \sin \theta) \quad\quad (4.19)$$
$$W = S(\cos \beta + i \sin \beta) \quad\quad (4.20)$$

$$Z \cdot W = RS[\cos(\theta + \beta) + i \sin(\theta + \beta)] \quad\quad (4.21)$$

Thus, the modulus of the product of two complex numbers is the product of the moduli of the two numbers, and the argument of the product of the two complex numbers is the sum of the arguments of the two numbers (Peitgen, Jurgens, and Saupe, 1992).

The theory of complex numbers extends far beyond the scope of this discussion. The information provided here is sufficient to begin to understand the basics of how Julia sets are produced.

Julia Sets

Julia sets are named after the mathematician Gaston Julia. He published his work in 1918, but until computers could generate images from his ideas, his sets did not receive widespread attention (Peitgen, Jurgens, and Saupe, 1992).

The quadratic family of Julia sets is the result of the iteration of the equation:

$$Z(n+1) = Z(n)^2 + C \tag{4.22}$$

where Z and C are complex numbers.

When this equation is iterated from some initial point on the complex plane $Z(0)$, there can be two results. One result is that the value of $Z(n)$ can grow to a very large number, eventually reaching infinity. This set of points on the complex plane is referred to as the escape set (E). The other result is that the value of $Z(n)$ will be contained within a bounded region. This set of points on the complex plane is referred to as the prisoner set (P). The following example (Peitgen, Jurgens, and Saupe, 1992) enhances an understanding of this concept through the exploration of the simplest Julia set, where the parameter $C = 0 + 0i$.

Start with the equation:

$$Z(n+1) = Z(n)^2 \tag{4.23}$$

Now explore what happens when three different points on the complex plane are iterated through a few steps.

The first point defined in polar coordinates is ($R = 0.6$, $\theta = 10°$).

	length	angle
Z	0.6	10
Z^2	0.36	20
Z^4	0.1296	40
Z^8	0.016796	80

The value of the modulus (R) is approaching zero on a curved path. This point on the complex plane is attracted to zero.

The second point defined in polar coordinates is ($R = 1.0$, $\theta = 10°$).

	length	angle
Z	1.0	10
Z^2	1.0	20
Z^4	1.0	40
Z^8	1.0	80

The value of the modulus (R) is constant at 1.0. The iteration points are rotating around the unit circle. This point on the complex plane is attracted to the unit circle.

The third point defined in polar coordinates is ($R = 2$, $\theta = 10°$).

	length	angle
Z	2.0	10
Z^2	4.0	20
Z^4	16.0	40
Z^8	256.0	80

The value of the modulus (R) is approaching infinity on a curved path. This point on the complex plane is attracted to infinity.

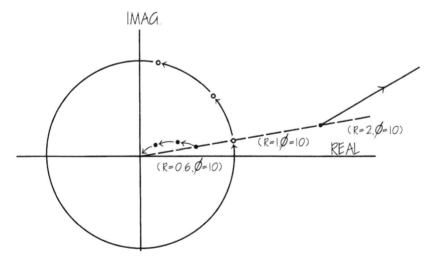

FIGURE 4.15 • The trajectories of the iterations of $Z(n + 1) = Z(n)^2$ for the initial values of Z equal to ($R = 0.6$, $\theta = 10°$), ($R = 1.0$, $\theta = 10°$), and ($R = 2$, $\theta = 10°$).

FIGURE 4.16 • The escape set approximations for iteration steps 0, 1, 2, 3, 4, 5, and 20 for the equation $Z(n+1) = Z(n)^2 + (-0.5 + 0.5i)$. Reproduced with permission from *Chaos and Fractals;* Peitgen, Jurgens, and Saupe; Springer-Verlag; 1992.

The boundary between the basin of attraction to the origin (to zero) and the basin of attraction to infinity is the unit circle in this simple case. The boundary between these two basins of attraction is called the Julia set. This is a special case where the Julia set is not a fractal.

Fractal Julia sets are produced when the parameter C has a value. The Julia set is developed by testing points on the complex plane to determine whether or not they are in the escape set or the prisoner set. In practice, the escape set is easier to determine, because once the absolute value of Z is large enough, the orbit will escape to infinity. The squaring of Z will overpower any effect that the constant C has on the iteration. Mathematical theory has shown that there is a value of Z that, once achieved, guarantees that the orbit of Z will be attracted to infinity and therefore be part of the escape set. This value is related to the parameter C and is given by the following formula:

$$r(C) = \text{(the absolute value of the modulus of C)}$$
$$\text{or 2, whichever is greater} \tag{4.24}$$

This information provides the basis for an algorithm to calculate the escape set. First, for the parameter C determine $r(C)$. This will result in a circle

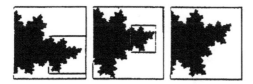

FIGURE 4.17 • The fractal characteristic of the Julia set for $Z(n+1) = Z(n)^2 + (-0.5 + 0.5i)$. Each succeeding picture is a blowup of the small framed region in the previous picture. Reproduced with permission from *Chaos and Fractals;* Peitgen, Jurgens, and Saupe; Springer-Verlag; 1992.

around the origin of the complex plane with a radius of $r(C)$. Next, iterate the equation through one step for all the pixel points inside the circle determined in step one, and compare the value of $Z(1)$ with $r(C)$. All points that are greater than or equal to $r(C)$ can be excluded from the next iteration because they will be part of the escape set. Repeating this procedure produces a better and better approximation of the boundary between the escape set and the prisoner set, which is the Julia set (Peitgen, Jurgens, and Saupe, 1992). Figure 4.16 shows this procedure for the equation:

$$Z(n+1) = Z(n)^2 + (-0.5 + 0.5i) \qquad (4.25)$$

The outer black circle represents $r(C) = 2$. Iteration steps 1, 2, 3, 4, 5, and 20 are shown on Figure 4.16. At Step 20 the Julia set is fairly well defined.

Figure 4.17 demonstrates the fractal characteristics of this Julia set through a zoom-in process. The detail of the set as one zooms in is not strictly self-similar because squaring in the equation produces nonlinear effects. However, Julia sets are not chaotic. Their structure is completely determined but infinitely complex.

FIGURE 4.18 • Various Julia sets from the quadratic family. Reproduced with permission from *The Science of Fractal Images;* Barnsley, Devaney, Mandelbrot, Peitgen, Saupe, and Voss; Springer-Verlag; 1988.

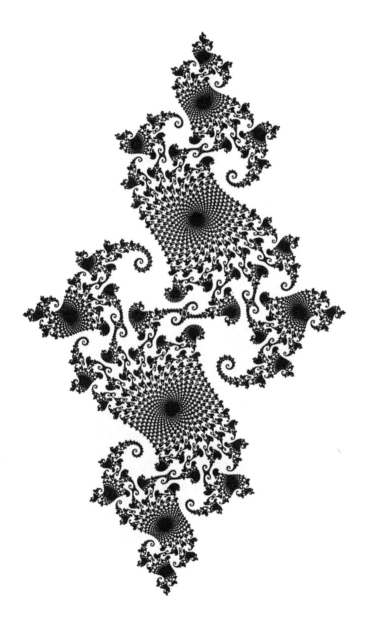

FIGURE 4.19 • The quadratic Julia set for $C = -0.74543 + 0.11301i$. Reproduced with permission from *The Science of Fractal Images;* Barnsley, Devaney, Mandelbrot, Peitgen, Saupe, and Voss; Springer-Verlag; 1988.

The Mandelbrot Set

Look back to Figure 4.18. Some of the Julia sets shown are connected. One can reach any location on the Julia set from anywhere else on the set without stepping off the set. Some of the Julia sets shown are disconnected into separate components. Whether a Julia set is connected or disconnected can be used to classify them into two groups. In 1979 Mandelbrot produced a picture of this two-part classification of Julia sets from the quadratic equation $Z(n + 1) = Z(n)^2 + C$. Figure 4.20 is a picture of this classification system. Mandelbrot tested each point of the complex plane C. If the value of C produced a connected Julia set, the pixel point of the display was shaded black. If the value of C produced a disconnected Julia set, the pixel point of the display was set to white (Peitgen, Jurgens, and Saupe, 1992).

Mandelbrot was aware of Julia's work, which showed that the Julia set for a parameter C would be connected only if the iterative sequence

$$C, (C^2 + C), [(C^2 + C)^2 + C], \ldots \tag{4.26}$$

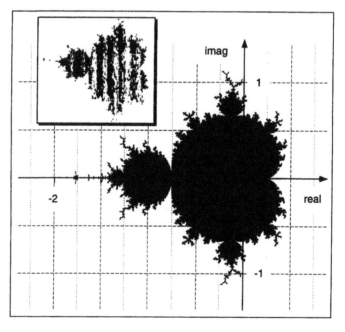

FIGURE 4.20 • The Mandelbrot set. The insert is a copy of the original printout from Mandelbrot's experiment. Reproduced with permission from *Chaos and Fractals;* Peitgen, Jurgens, and Saupe; Springer-Verlag; 1992.

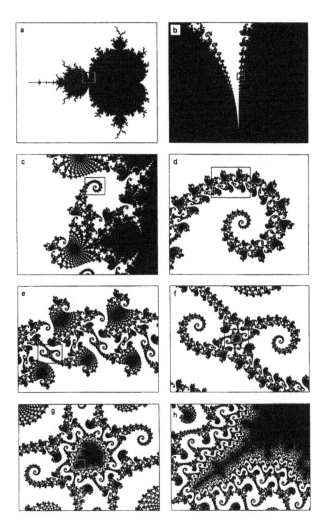

FIGURE 4.21 • A zoom-in sequence on the edge of the Mandelbrot set. Reproduced with permission from *Chaos and Fractals;* Peitgen, Jurgens, and Saupe; Springer- Verlag; 1992.

is bounded. If this sequence grows in value, then the Julia set for C will be disconnected. This is the basis for the algorithm that produces the Mandelbrot set (Peitgen, Jurgens, and Saupe, 1992). The Mandelbrot set is a fantastically complex entity. Figure 4.21 shows a zoom-in sequence on the edge of the Mandelbrot set. The edge represents the boundary between connected and disconnected quadratic Julia sets. The Mandelbrot set, like Julia sets, has infinite complexity, but it is deterministic, not chaotic. Every time it is generated, it will come out exactly the same way.

If the reader wants to explore the creation of Julia sets or the Mandelbrot set there are various computer programs available. Two such programs are.

Mandella
This program comes with the book *Fractals for the Macintosh*
Jesse Jones
The Waite Group, 1993

The Desktop Fractal Design System
Michael Barnsley
Academic Press, 1992

Mandella has more flexibility in the generation of Julia sets and the Mandelbrot set. It can zoom-in and print the images produced. *The Desktop Fractal Design System* has a very interesting display of the Mandelbrot set with the corresponding Julia set next to it. The user can click on the image of the Mandelbrot set and the Julia set for that point inside or outside the Mandelbrot set is drawn in the Julia set screen. This makes it easy to explore sequences of Julia sets. However, the program does not allow the user to print any of these images.

Further Study

Look over the Julia sets and the zoom-in of the Mandelbrot set. The shapes are somehow pleasant in appearance. What they have is a clustered and approximate self-similarity from one area of the image to another and from one zoom-in of the image to another. A similar, clustered, approximate self-similarity is displayed throughout nature. Go for a walk; look at the trees, clouds, mountain ridges, river valleys, and stars. The fractal images of Julia, Mandelbrot, and others are pleasant because they capture the character and depth of texture that nature displays. Our perceptual mechanisms evolved in nature and therefore respond to a similar textural quality. The study of fractal geometry should help the designer achieve a better understanding of the cascade of detail all around us in the natural world.

Sketch some trees with an eye for the cascade of clumps of similar shape that make up the tree form. Compare different tree species.

Chaos and Fractals by Peitgen, Jurgens, and Saupe provides a very complete description of Iterated Function Systems and Julia sets.

Figure 4.22 is a drawing of an Art Deco terra-cotta facade decoration in a theater. Compare the images of Julia sets in *The Science of Fractal Images* by Barnsley, Devaney, Mandelbrot, Peitgen, Saupe, and Voss with the Art Deco designs in *Rediscovering Art Deco* by Capitman, Kinerk, and Wilhelm.

FIGURE 4.22 • A drawing of a terra-cotta facade decoration in a theater.

5 | Random Fractals, Midpoint Displacement, and Curdling

Random Fractals

Randomness can be introduced into the generation process of fractals through the use of coin tossing, dice, or random numbers. The Koch curve provides a good example of how this process can work. The generation of the Koch curve calls for a triangular blip to be added to the center part of each straight-line segment at each stage of the generation of the curve. A coin can be used to decide in a random fashion whether the blip should go up or down each time one is to be added.

Archimedes and the Area Under a Parabola

Midpoint displacement can be traced back to Archimedes (287–212 B.C.). Archimedes used midpoint displacement to evaluate the area under a parabola (Barnsley et al., 1988). Draw a parabola with a straight line across its base. Then draw a line from the center of the baseline up to the parabola and

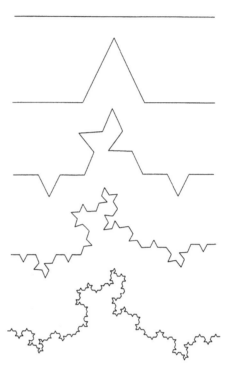

FIGURE 5.1 • The Koch curve generated using a coin flip to decide whether the blip goes up or down.

connect this point with the endpoints of the baseline, as in Figure 5.2. The sum of these two triangles is a first approximation of the area between the base line and the curve of the parabola.

In the next step the same procedure is repeated in the two areas that are left between the triangles that were drawn in Figure 5.2 and the parabola. The

FIGURE 5.2 • The first step in determining the area under a parabola by the Archimedes method.

FIGURE 5.3 • The second stage in the Archimedes method of determining the area under a parabola.

area left between the collection of triangles and the parabola will get progressively smaller as more triangles are added to the process. The second stage of the process is shown in Figure 5.3.

The procedure continues in a recursive fashion until the area not included in the collection of triangles represents an acceptably small error. Each step doubles the number of triangles used. If one measures the difference in the height of the vertical lines used to construct the triangles from one stage to the next stage, an interesting relationship is revealed. The heights of the vertical lines are related by a constant from one stage to the next. This relationship is given by the following formula:

$$\text{height}(n + 1) = \left(\frac{1}{4}\right)\text{height}(n) \tag{5.1}$$

where $n =$ the step number $(1, 2, 3, 4, \ldots)$.

This relationship between the lengths of the vertical-line segments from one stage to the next stage can then be used to recursively generate an approximation of a parabola. Figure 5.4 shows an approximation of a parabola taken

FIGURE 5.4 • Generating a Parabola with the Archimedes Method.

through three stages of the recursive process. In the limit of an infinite number of stages a smooth parabola will result (Barnsley et al., 1988).

Fractal Curves by the Archimedes Midpoint Displacement Method

A mathematician named Landsberg extended the Archimedes procedure for constructing a parabola to arbitrary scaling factors for the vertical lines from one stage of the construction to the next. He discovered that when the vertical lines were scaled by the factor (w) as shown in the formula:

$$\text{height}(n+1) = (w)\text{height}(n) \tag{5.2}$$

where $n =$ the step number $(1, 2, 3, 4, \ldots)$, the curves are fractal for the range $1/2 \leq w \leq 1.0$. He also showed that the fractal dimension of the curves is given by the formula:

$$D = 2 - |\log_2 w| \tag{5.3}$$

This equation uses logarithms with a base of 2. The (y^x) function on a calculator can be used to set up a table relating the scaling factor (w) to the resulting fractal dimension of the curve produced. In base 10 logarithms $(\log_{10}(100) = 2)$ because $(100 = 10^2)$. Similarly in base 2 logarithms $\left(\log_2(0.707) = -0.5\right)$ because $(0.707 = 2^{-0.5})$. Thus, the scaling factors for fractal dimensions from 1.1 to 1.9 in increments of 0.1 are given by the following formula where $(\log_2 w)$ is incremented from -0.9 to -0.1:

$$w = 2^{(\log_2 w)} \tag{5.4}$$

To create a curve that approaches a fractal dimension of 1.3 as the generation stages approach infinity, start with a horizontal straight line. Draw a vertical line of any length up from the center of the horizontal line. Connect the ends of the horizontal line with the top of the vertical line to create two triangles. This completes the first stage of a recursive process. In the second stage draw vertical lines parallel to the original vertical line up from the center of the sloping lines that created the two triangles. For this curve to have a specific fractal dimension, these new vertical lines need to be scaled properly:

$$\text{length of vertical lines}(n+1) = (w)\text{length of vertical lines}(n) \tag{5.5}$$

TABLE 5.1 • Scaling Factor Related to Fractal Dimension

Fractal Dimension (D)	$\log^2 w$	Scaling Factor (w)
1.9	-0.1	0.933
1.8	-0.2	0.871
1.7	-0.3	0.812
1.6	-0.4	0.758
1.5	-0.5	0.707
1.4	-0.6	0.660
1.3	-0.7	0.616
1.2	-0.8	0.574
1.1	-0.9	0.536
1.0	-1.0	0.500

where n = the step number $(1, 2, 3, 4, \ldots)$, for the fractal dimension to approach 1.3, $w = 0.616$.

This recursive process is repeated to infinity to produce a mathematical fractal with a fractal dimension of 1.3 across all scales. In real life the process continues until the display method loses the ability to display additional resolution. Figure 5.5 shows the development of a fractal curve with the fractal dimension 1.3 through five stages of development.

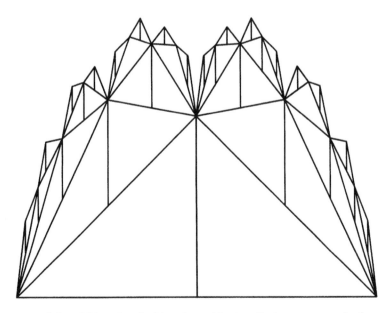

FIGURE 5.5 • Using the Archimedes midpoint displacement method to create a curve with a fractal dimension approaching 1.3 as the generation stages approach infinity.

Random Fractal Curves with the Archimedes Midpoint Displacement Method

The fractal curve shown in Figure 5.5 has a clustered texture that is similar to natural shapes. However, nature's textures have a random component to their clustering. Including a random component is very simple. Flip a coin to determine whether each of the vertical lines that are added during each stage of the construction will go up or down from the center point of the line from which it is being constructed. Random number tables or a random number generation program on a computer can also provide a random selection for each of the vertical lines. Figure 5.6 shows the construction of a random midpoint

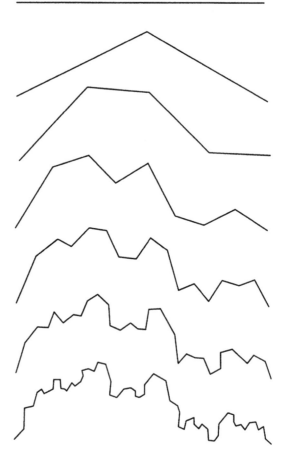

FIGURE 5.6 • Midpoint displacement generation of a random curve with a fractal dimension that will approach 1.3 as the generation stages approach infinity.

displacement fractal curve with a fractal dimension that will approach 1.3 as the generation stages approach infinity. It is shown developed through seven stages.

The same sequence of random flips of a coin was used to generate both Figure 5.6 and Figure 5.7 so that a visual comparison could be made between the two curves. The difference goes beyond the scaling up of the texture of the smoother curve. Figure 5.8 shows the seventh stage of the curves developed in the previous two figures superimposed on each other. The curve with the higher fractal dimension has more variation at the large and the small scale compared to the curve with the smaller fractal dimension.

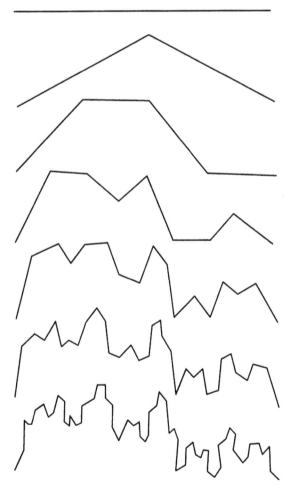

FIGURE 5.7 • Midpoint displacement generation of a random curve with a fractal dimension that will approach 1.6 as the generation stages approach infinity.

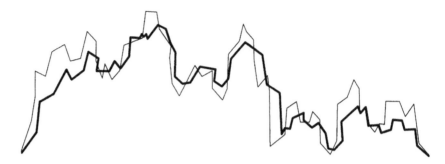

FIGURE 5.8 • Fractal curves from Figures 5.6 and 5.7 superimposed on each other.

Gaussian Midpoint Displacement

Gaussian midpoint displacement is a more complex form of the simple midpoint displacement method covered above. The same basic procedure is followed except the displacement at each step along the way is determined by a random choice from a Gaussian distribution. Figure 5.9 shows a Gaussian distribution centered around the origin. Some of the displacements chosen at random from the curve will be positive and some will be negative; some of the displacements will be large and some will be small.

The displacement at each step along the way will be scaled by a factor referred to as the Hurst exponent. The Hurst exponent varies between 0 and 1. When the Hurst exponent is equal to 0.5, the distribution produced is referred to as brown noise because of its relationship to Brownian motion. As the Hurst exponent (H) varies, the scaling factor varies in the following way:

FIGURE 5.9 • A Gaussian distribution centered at zero.

$$\text{for } H = 0.3 \quad W = \frac{1}{(2)^H} = \frac{1}{1.231} = 0.812 \qquad (5.6)$$

$$\text{for } H = 0.5 \quad W = \frac{1}{(2)^H} = \frac{1}{1.414} = 0.707 \qquad (5.7)$$

$$\text{for } H = 0.7 \quad W = \frac{1}{(2)^H} = \frac{1}{1.625} = 0.615 \qquad (5.8)$$

Thus, as the Hurst exponent gets larger, the scaling factor gets smaller. As the scaling factor gets smaller, the fluctuations in the midpoint displacement process get smaller. There is a relationship between the Hurst exponent (H) and the fractal dimension (D) of the resulting curve produced by the midpoint displacement process:

$$D = 2 - H \qquad (5.9)$$

Computer programs are available that can produce a brown variation with random midpoint displacement. This is the case when the Hurst exponent is equal to 1/2. There are also algorithms for producing curves from midpoint displacement where the Hurst exponent can be varied from 0 to 1. Figure 5.10 shows a graph of five curves produced with one of these algorithms. The Hurst

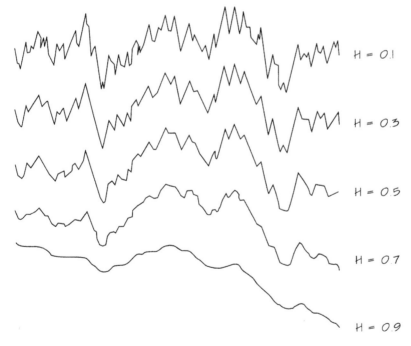

FIGURE 5.10 • Fractal noise generated with the algorithm MidPointFMID. *H* indicates the Hurst exponent. Reproduced with permission from *The Science of Fractal Images*; Barnsley, Devaney, Mandelbrot, Peitgen, Saupe, and Voss; Springer-Verlag; 1988.

exponents of these curves are 0.9, 0.7, 0.5, 0.3, and 0.1. The resulting fractal dimensions are 1.1, 1.3, 1.5, 1.7, and 1.9.

Scaling Brownian Noise

The fractal noise fluctuations displayed in Figure 5.10 are statistically self-similar. One section of the noise is not exactly the same as other sections, but all sections are statistically similar. What happens when a small section of the noise is magnified and observed at a larger scale? If the scaling is equal on both the vertical and the horizontal axis and is repeated over and over again, the resulting curves become much rougher than the original curve. If the scaling is 1 in the vertical direction and 2 in the horizontal direction, the result is that the curves flatten out. Figure 5.11 shows both these situations. Brown noise should retain its character no matter how closely we observe it. This is clearly not the case with either of these scalings.

There should be a vertical scaling factor between 1 and 2 that will produce a statistically self-similar curve. The scaling factors that result in a statistically self-similar curve after scaling are the following:

$$\text{horizontal scaling} = 2 \qquad (5.10)$$
$$\text{vertical scaling} = \sqrt{2} \qquad (5.11)$$

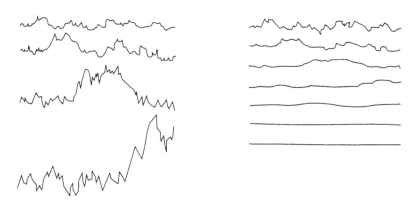

FIGURE 5.11 • Brown noise with a scaling factor of 2 in both the vertical and horizontal directions on the left, and the same brown noise with a vertical scaling factor of 1 and a horizontal scaling factor of 2 on the right. The original curve is on the top. The curves below are progressively rescaled. Reproduced with permission from *Chaos and Fractals*; Peitgen, Jurgens, and Saupe; Springer-Verlag; 1992.

Figure 5.12 shows brown noise rescaled in the vertical direction by $\sqrt{2}$ and in the horizontal direction by 2. This is a proper rescaling of brown noise produced from a Hurst exponent of 0.5. It does not change the character of the noise.

The above scaling factors apply to brown noise with a Hurst exponent of 0.5 and a fractal dimension of 1.5. This scaling of the vertical dimension can be extended to produce a range of fractal curves by using the following scaling factors:

$$\text{horizontal scaling} = 2 \qquad (5.12)$$

vertical scaling is related to the Hurst exponent (H), which is related to the fractal dimension ($D = 2 - H$)

$$\text{vertical scaling} = 2^H \qquad (5.13)$$

This solves the scaling problem and introduces another problem. The fact that the vertical scaling and horizontal scaling are not equal when a zoom-in on these noise curves is performed means that the methods explained in Chapter 3 for experimentally determining fractal dimension (the measured dimension and the box counting dimension) will not produce correct results. It is necessary to know the Hurst exponent to determine the fractal dimension correctly.

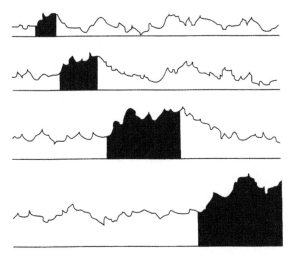

FIGURE 5.12 • Properly rescaled brown noise. The vertical scaling is $\sqrt{2}$, and the horizontal scaling is 2. Reproduced with permission from *Chaos and Fractals*; Peitgen, Jurgens, and Saupe; Springer-Verlag; 1992.

Determining the Hurst Exponent

H. E. Hurst was a hydrologist who studied the variation of natural systems through time. His studies ranged from temperature and pressure variation through lake levels and river discharges to tree rings. He compared the variation of these natural systems by calculating what is now called the Hurst exponent. He used a process known as rescaled range analysis. Remember that the fractal dimension (D) is related to the Hurst exponent (H) by the following equation:

$$D = 2 - H \qquad (5.14)$$

Rescaled range analysis looks at the size of the maximum fluctuation of a variable over a range of time scales. As an example, consider a reservoir. The water level will fluctuate depending on the inflow and outflow of water. The difference between the lowest and the highest recorded level will be larger as the period of time over which one observes the reservoir is longer (Feder, 1988). Figure 5.13 shows two curves taken from Figure 5.10 with fractal dimensions

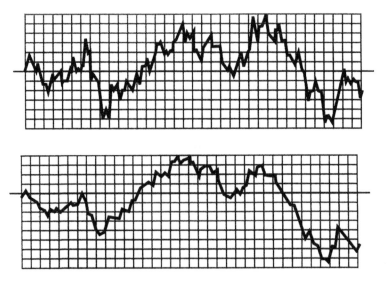

F I G U R E 5.13(a) • Fractal noise curves with $D = 1.7$ and 1.3 with a measuring grid superimposed on them.

of 1.7 and 1.3. A grid has been placed over the curves so that measurements of the maximum fluctuation in the vertical direction can be made. Figure 5.13(a) shows the curves as one entity. Both curves show a maximum fluctuation from the lowest to the highest level of 11 units.

Figure 5.13(b) shows the curves divided into two pieces. This represents a time length of (1/2) of the initial time length. The average maximum fluctuation is calculated by averaging the maximum fluctuation for each of the two segments of the curves.

For the upper curve ($D = 1.7$), the two maximum fluctuations are 10 and 11.5, resulting in an average maximum fluctuation of 10.75.

For the lower curve ($D = 1.3$), the two maximum fluctuations are 8.25 and 10.4, resulting in an average maximum fluctuation of 9.325.

Figure 5.13(c) shows the curves divided into four pieces. This represents a time length of (1/4) of the initial time length. The average maximum fluctuation is calculated by averaging the maximum fluctuation for each of the four segments of the curves.

For the upper curve ($D = 1.7$), the four maximum fluctuations are 8.5, 10, 6.75 and 10.5, resulting in an average maximum fluctuation of 8.938.

For the lower curve ($D = 1.3$), the four maximum fluctuations are 4.75, 7.75, 3.75, and 9.25, resulting in an average maximum fluctuation of 6.375.

FIGURE 5.13(b) • Fractal noise curves with $D = 1.7$ and 1.3 divided into two halves.

FIGURE 5.13(c) • Fractal noise curves with $D = 1.7$ and 1.3 divided into four quarters.

FIGURE 5.13(d) • Fractal noise curves with $D = 1.7$ and 1.3 divided into eight eighths.

Figure 5.13(d) shows the curves divided into eight pieces. This represents a time length of (1/8) of the initial time length. The average maximum fluctuation is calculated by averaging the maximum fluctuation for each of the eight segments of the curves.

For the upper curve ($D = 1.7$), the eight maximum fluctuations are 4, 8.5, 5.5, 5, 4.75, 6.75, 8.5 and 5.75, resulting in an average maximum fluctuation of 6.094.

For the lower curve ($D = 1.3$), the eight maximum fluctuations are 2.5, 4.5, 5, 2.75, 3.75, 3.5, 6.5 and 3.75, resulting in an average maximum fluctuation of 4.031.

The maximum fluctuation ranges calculated in Figure 5.13 would not change if the horizontal axis of the two curves was stretched or shrunk. The maximum fluctuation range for the entire time period and the average maximum fluctuation ranges for the (1/2), (1/4), and (1/8) time periods would still be the same even though the curves would look much smoother if the horizontal axis was stretched out and much rougher if the horizontal axis was compressed. This is an important feature of rescaled range analysis. It is not affected by the arbitrary stretching or shrinking of the horizontal (time) axis.

The Hurst exponent is determined by graphing the log(maximum fluctuation range) versus the log(time scale). A linear regression on this set of data points will determine the best straight line that represents the data. The slope of the linear regression line is the experimentally determined Hurst exponent (H).

For the upper curve, which was generated to have a fractal dimension of 1.7 and thus a Hurst exponent of 0.3, the data necessary to do a linear regression is shown in Table 5.2.

TABLE 5.2 • Log-log calculation for the curve with $D = 1.7$

time scale	maximum fluctuation range
1	11
1/2	10.75
1/4	8.938
1/8	6.094
1/16	3.813

log(time scale)	log(maximum fluctuation range)
0	1.041
−0.301	1.031
−0.602	0.951
−0.903	0.785
−1.204	0.581

Many scientific calculators have statistical functions including linear regression. A linear regression of the log-log data above results in a line with a slope of 0.387. Thus, the Hurst exponent (H) calculated for this data is estimated to be 0.387. The fractal dimension of the data is given by the following equation:

$$D = 2 - H$$
$$D = 2 - 0.387$$
$$D = 1.61$$

For the lower curve, which was generated to have a fractal dimension of 1.3 and thus a Hurst exponent of 0.7, the data necessary to do a linear regression is shown in Table 5.3.

A linear regression of the log-log data from Table 5.3 results in a line with a slope of 0.560. Thus, the Hurst exponent (H) calculated for this data is estimated to be 0.560. The fractal dimension of the data is given by the following equation:

$$D = 2 - H$$
$$D = 2 - 0.560$$
$$D = 1.44$$

The algorithms used to generate fractal noise curves are approximate in their simulation. The result of this approximation is that curves generated to have fractal dimensions above $D = 1.5$ will have measured fractal dimensions that are slightly lower than the desired value, and curves generated to have fractal dimensions below $D = 1.5$ will have measured fractal dimensions that are

TABLE 5.3 • Log-log calculation for the curve with $D = 1.3$

time scale	maximum fluctuation range
1	11
1/2	9.325
1/4	6.375
1/8	4.031
1/16	2.406
log(time scale)	*log(maximum fluctuation range)*
0	1.041
−0.301	0.970
−0.602	0.804
−0.903	0.605
−1.204	0.381

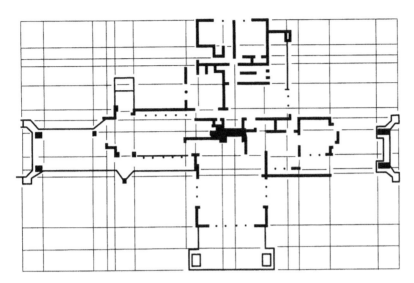

FIGURE 5.14 • A planning grid based on the major plan elements of Frank Lloyd Wright's Willits house.

slightly higher than the desired value (Feder, 1988). The curve that was generated to have a fractal dimension of 1.7 was measured at 1.61 by rescaled range analysis. The curve that was generated to have a fractal dimension of 1.3 was measured at 1.44 by rescaled range analysis.

Rescaled range analysis is an important tool for measuring the fractal dimension of rhythms from nature, art, or architectural compositions because it is not affected by arbitrary stretching or compression of the horizontal axis. Transferring a rhythm onto a noise plot like Figure 5.13 will always result in an arbitrary horizontal axis.

As an example, consider the rhythms created by Frank Lloyd Wright's floor plans. Figure 5.14 shows a planning grid based on the major elements of Frank Lloyd Wright's Willits house.

The rhythms of the plan can be translated into a fractal noise curve by making a bar chart from the rhythmic variation. In Figure 5.15 the height of each bar represents the variation in width of the horizontal and then vertical

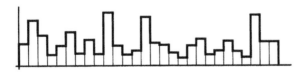

FIGURE 5.15 • Bar chart of the rhythms of Frank Lloyd Wright's Willits house.

grid lines across the Willits house floor plan. The step function across the tops of the bars can then be subjected to rescaled range analysis to determine the Hurst exponent and thus the fractal dimension of the rhythm. How wide or narrow the individual bars are drawn will not affect the rescaled range analysis calculation. The larger the rhythm sample used, the more accurate the result will be.

Fractal Rhythms

Midpoint displacement generated brown noise can be used to produce fractal rhythms for design purposes. The first step is to generate the brown noise. Then a datum line is placed over the noise distribution. The vertical displacement above or below the datum line will produce the fractal rhythm for the design project. Figure 5.13 shows the brown noise curves from Figure 5.10

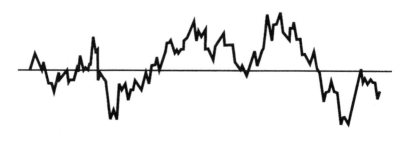

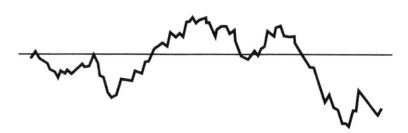

FIGURE 5.16 • Fractal noise curves with $D = 1.7$ and $D = 1.3$ with datum lines drawn through them.

generated from Hurst exponents of 0.3 and 0.7. On Figure 5.16, a datum line has been drawn through the center of the noise distributions.

In architectural design it is helpful if the variation determined from the fractal curves is represented in modular steps. Architecture is built from pieces that are manufactured in modular size increments.

In order to extract a modular variation from the curves, a grid is placed over the curves to resolve them into step functions. The grid size is related to the number of modular steps the designer wants to use in the design variation. Figure 5.17 shows the two fractal curves with a grid superimposed on them.

The next step is to resolve the curves into step functions so modular fractal rhythms can be determined. Figure 5.18 shows the two curves translated into step functions with the vertical datum placed over the curves. Fractal rhythms can now be read off the curves. The values will be discrete steps that can be related to discrete size differences. The process of using this fractal rhythm information will be explained in Chapter 7.

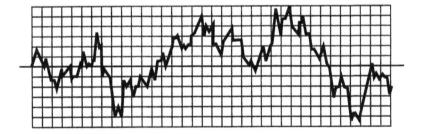

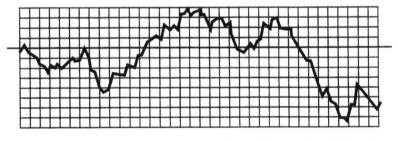

FIGURE 5.17 • Fractal noise curves with $D = 1.7$ and $D = 1.3$ with a grid superimposed on them.

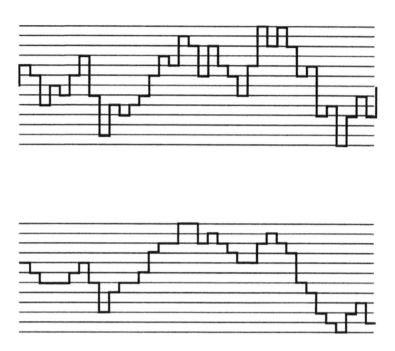

FIGURE 5.18 • Fractal step functions based on noise curves with fractal dimensions of 1.7 and 1.3.

Curdling

Curdling is the name Mandelbrot gave to a process that produces a fractal dust. A fractal dust is a disconnected set of points that has a clustered characteristic. The Cantor set, Figure 2.1, is an example of a fractal dust where randomness is not present. The set of stars in the night sky is an example of a fractal dust where there is a random component to the clustering.

The curdling process is very simple. Start with a grid drawn on a piece of paper. Then, through the use of a coin, a die, or a random number generator, a decision is made to keep or discard each of the squares of the grid. The concept is that the mass of material spread over the initial area curdles onto the squares that are chosen by the random process to remain into the next stage of generation. Figure 5.19 shows the use of a nine square grid.

Using a coin is the easiest method. Flip the coin for each of the nine squares. A head means the square survives to the next round. A tail means the square disappears. The probability of survival with a coin toss is (1/2). At the next level each of the surviving squares is subdivided into nine smaller squares.

FIGURE 5.19 • The initial nine square grid after the first stage of the curdling process. Three of the nine squares remain.

The coin is again used to decide which of the smaller squares survives to the next round. Ideally, this procedure is repeated to infinity, leaving a dust of points. In reality the procedure is repeated until the resolution of the display device is reached. Figures 5.20, 5.21, and 5.22 show curdling with probabilities of (1/2), (2/3) and (1/3). A die was used to achieve the (2/3) and (1/3) probabilities.

At each level of the process the area where future dust can be located is narrowed down to part of the overall area. Thus the process slowly clumps the dust together into clusters of points. These three examples used the same probability through all the generation stages. It is acceptable to curdle with different probabilities at different stages of the generation process (Mandelbrot, 1983).

The fractal dimension of these dusts can be calculated using the box-counting method. Since there is a random process involved, the larger the sample used, the more accurate the results will be. Thus, the box-counting dimension determined from the second and third stages will be a more accurate measure of the fractal dimension of the dust than that obtained by using the first and second stages.

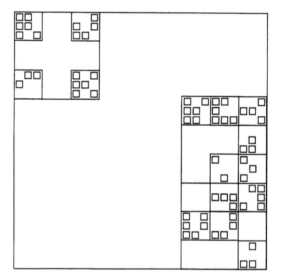

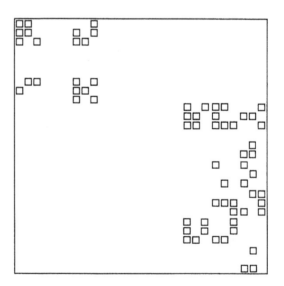

FIGURE 5.20 • Curdling with a probability of (1/2). The upper figure shows three stages of curdling superimposed. The lower figure is the resulting fractal dust.

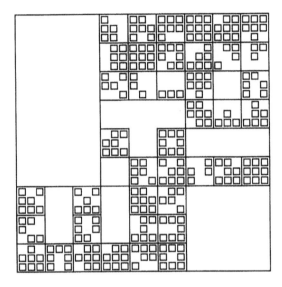

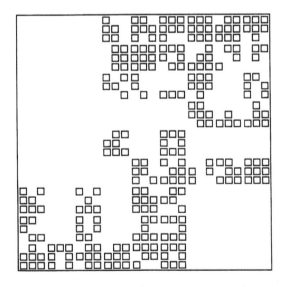

FIGURE 5.21 • Curdling with a probability of (2/3). The upper figure shows three stages of curdling superimposed. The lower figure is the resulting fractal dust.

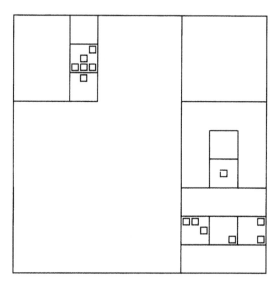

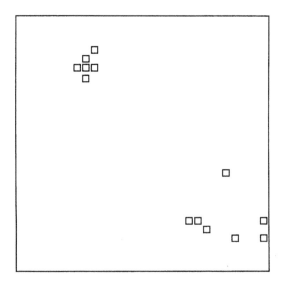

FIGURE 5.22 • Curdling with a probability of (1/3). The upper figure shows three stages of curdling superimposed. The lower figure is the resulting fractal dust.

The box-counting dimension for the dust with probability (2/3) is calculated as follows:

boxes count	grid size	grid dimension
41	9	1/9
259	27	1/27

$$D\left[\text{box}, \left(\frac{1}{9}\right) - \left(\frac{1}{27}\right)\right] = \frac{[\log(259) - \log(41)]}{[\log(27) - \log(9)]}$$

$$= \frac{(2.413 - 1.613)}{(0.954 - 0.477)}$$

$$= \frac{0.835}{0.477}$$

$$= 1.678$$

The box-counting dimension for the dust with probability 1/2 is calculated as follows.

boxes count	grid size	grid dimension
15	9	1/9
66	27	1/27

$$D\left[\text{box}, \left(\frac{1}{9}\right) - \left(\frac{1}{27}\right)\right] = \frac{[\log(66) - \log(15)]}{[\log(27) - \log(9)]}$$

$$= \frac{(1.820 - 1.176)}{(0.954 - 0.477)}$$

$$= \frac{0.644}{0.477}$$

$$= 1.350$$

The box-counting dimension for the dust with probability (1/3) is calculated as follows.

boxes count	grid size	grid dimension
7	9	1/9
13	27	1/27

$$D\left[\text{box},\left(\frac{1}{9}\right)-\left(\frac{1}{27}\right)\right] = \frac{\left[\log(13)-\log(7)\right]}{\left[\log(27)-\log(9)\right]}$$
$$= \frac{(1.114-0.845)}{(0.954-0.477)}$$
$$= \frac{0.269}{0.477}$$
$$= 0.564$$

One more calculation is useful in understanding the range of possibilities. At a probability of 1.0, all of the squares would remain in the process throughout the entire process.

The box-counting dimension for the dust with probability (1) is calculated as follows.

boxes count	grid size	grid dimension
81	9	1/9
729	27	1/27

$$D\left[\text{box},\left(\frac{1}{9}\right)-\left(\frac{1}{27}\right)\right] = \frac{\left[\log(729)-\log(81)\right]}{\left[log(27)-log(9)\right]}$$
$$= \frac{(2.863-1.908)}{(0.954-0.477)}$$
$$= \frac{0.955}{0.477}$$
$$= 2.00$$

Figure 5.23 is a graph of the probability used to create the fractal dust in relation to the fractal dimension of the dust. At a probability of (1), the fractal dimension is 2.00. The area is filled with dust since all squares at all levels remained in the process. Plotting the other three cases and projecting the graph over to the Y-axis suggests that the probability must be above a value of about 0.2 for there to be a fractal dimension. This is shown as curve A. What does this mean?

One more experiment will help explain. Think about the nine square grid. If the probability was (1/9), then at the first stage one would expect that one square would be chosen to remain. At the second stage there are again

FIGURE 5.23 • Probability used in curdling in relation to the box-counting dimension.

nine chances for a square to be chosen, so one would again expect that one square would be chosen to remain. Thus, in the ideal case one square will remain at each stage of the curdling. In a real situation it is possible that more than one square might be chosen at a given stage, or that no squares might be chosen. At any lower probability there is a high likelihood that no squares will be chosen fairly soon in the curdling process. If one square is chosen at each stage, the box-counting dimension would be 0.00, since the numerator in the calculation would be $[(\log 1 - \log 1) = 0.00]$. If at some stage no boxes are chosen, then the box-counting dimension would be 0.00, since there would be no dust to use in a calculation. Thus, the curve relating probability used in curdling to the box-counting dimension for the nine square grid should begin at probability equal to (1/9) for a box-counting dimension of 0.00. The curve needs to end at a point where probability is equal to 1.00 and the box-counting dimension is equal to 2.00. Curve *B* on Figure 5.23 is an approximation of this curve that represents what the relationship should be between probability of curdling and box-counting dimension after an infinite number of generations of curdling.

The shape of this curve is of some interest. It is not linear; there is an exponential relationship. From a qualitative standpoint, the exponential relationship may indicate that there are unequal visual differences between fractal

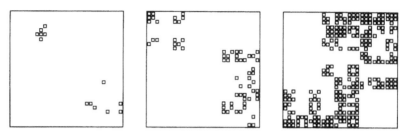

FIGURE 5.24 • Comparison of visual interest and fractal dimension. From left to right the dusts have fractal dimensions of 0.564, 1.350, and 1.678. The difference between the fractal dimensions of the first and the middle is almost twice the difference between the fractal dimensions of the middle and the last figure.

dusts depending on where they are on the fractal dimension scale. Figure 5.24 makes this visual comparison. From left to right the dusts have fractal dimensions of 0.564, 1.350, and 1.678. The difference between the fractal dimensions of the first figure and the middle figure is almost twice the difference between that of the middle figure and the last figure, yet the visual jump in interest seems about the same.

Mandelbrot introduces curdling as a method of modeling the process that produced the stars and galaxy clusters in the sky. He notes that the stars have a fractal dimension of 1.23 (Mandelbrot, 1983). He makes the point that if the stars and galaxies were not a fractal dust, if they were distributed evenly over

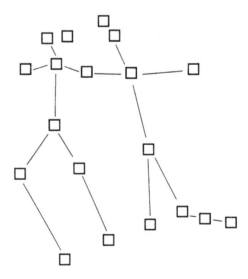

FIGURE 5.25 • The fractal dust of stars from the constellation Gemini (the twins).

the universe, then the night sky would have an even glow of light. There would not be the patterns of stars that generations of humans have projected their thoughts onto.

Further Study

Compare equations 5.6, 5.7, and 5.8 with the scaling factors developed in Table 5.1. What is the relationship between $(\log_2 w)$ in Table 5.1 and H in equations 5.6, 5.7, and 5.8? Remember that $y^{-x} = 1/y^x$.

Using a coin toss for a probability of (1/2) and a nine square grid, produce 10 different fractal dust patterns. Calculate the fractal dimension of the 10 different dusts. What range of fractal dimension does this produce?

Look through the book *Powers of Ten* by Philip and Phylis Morrison and the office of Charles and Ray Eams, or view the film *Powers of Ten* by Charles and Ray Eams. The book and the film provide wonderful images of how matter and energy in the universe are not evenly distributed. They are clumped. The book and movie display this clumped distribution from the scale of galaxies to the scale of atoms.

Mandelbrot includes randomness in his discussion of fractals in *The Fractal Geometry of Nature* from page 200 to the end of the book.

Fractals by Hastings and Sugihara provides a description of how to use Fourier transforms to produce random fractals.

6 | Natural and Fractal Fluctuations in Time, Noise, and Music

White and Brown Noise

Noise is an unpredictable variation of some variable in time. White noise is a completely random variation in time. This means that for short or long time intervals there is no correlation between one segment of the variation and any other. If one integrates this random or white noise, the result is brown noise. Brown noise has a fairly strong statistical correlation between different segments of the variation. Brown noise has more low frequency than high frequency fluctuations. It receives its name because it is a good model of Brownian motion (Barnsley et al., 1988). Brownian motion is the term given to the random motion of a very fine particle suspended in a liquid. The thermal motion of the molecules of the liquid push the particle around in a random fashion. The position of the particle in the fluid is highly correlated to previous positions of the particle.

A die can be used to simulate these two varieties of noise. On a piece of graph paper draw a horizontal line. Mark the vertical axis with plus and minus whole numbers.

White noise is generated by throwing the die and marking a sequence of positions with the numbers 1, 2, 3, 4, 5, or 6 that the die produces. There is no correlation between throws of the die.

Brown noise is generated in the following manner. Use the same graphic setup that was used for white noise. Throw the die once to get the starting position. Then on subsequent throws, go up one step on the vertical scale if the die shows an odd number. Go down one step on the vertical scale if the die shows an even number. The sequence produced will be an example of brown noise (Gardner, 1978). Figure 6.1 shows the generation of white and brown noise.

An auto correlation function measures how fluctuations at one moment are related to earlier fluctuations. How an auto correlation is done is not important to the intent of this book, but some of the terminology is useful in defining features of noise. White noise is referred to as $1/f^0$ noise (f = frequency) because there is no correlation between segments of the noise. A graph of the log of the spectral density on the Y-axis compared to the log of the frequency on the X-axis will result in a line with a slope very close

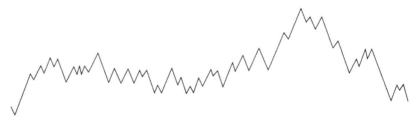

F I G U R E 6.1 • White and brown noise generated with the throws of a die. The upper curve is white noise; the lower curve is brown noise. Adapted with permission from "Mathematical Games," Martin Gardner, *Scientific American*, April 1978.

to zero. All frequencies are present, fluctuating with roughly equal amplitudes. Static on a radio is a good example of this type of noise. Brown noise is referred to as $1/f^2$ noise because there is a correlation between fluctuations at one moment and fluctuations at earlier and later moments. A graph of the log of the spectral density on the Y-axis compared to the log of the frequency on the X-axis will result in a line with a slope very close to two. There are more low frequency, slow developing fluctuations than high frequency, fast developing fluctuations. Brown noise has a mix of order and surprise. White noise is all surprise.

$1/f$ Noise

There is an important noise type that has a variability that lies between white and brown noise. This noise is referred to as $1/f$ noise. This mix of order and surprise shows up in the way nature changes through time from flood levels of the Nile River to voltage fluctuations in nerve cells (Barnsley et al., 1988). T. Musha, of the Tokyo Institute of Technology has shown that traffic flow on an expressway is a $1/f$ fluctuation. He also rotated a radar disk at a seacoast location. The first rotation produced a brown distribution of the distances of all the objects from the radar location. He rotated the radar again, subtracting the two distributions to get a picture of how the situation changed in time. The change in time was close to a $1/f$ variation (Gardner, 1978).

In an article in *Scientific American*, Martin Gardner summarizes the relationship between $1/f$ noise and nature's changability:

> The changing landscape of the world (or to put it another way the changing content of our total experience) seems to cluster around $1/f$ noise. It is certainly not entirely uncorrelated, like white noise, nor is it as strongly correlated as brown noise. From the cradle to the grave our brain is processing the fluctuating data that come to it from the sensors. If we measure this noise at the peripheries of the nervous system (under the skin of the fingers), it tends, Mandelbrot says, to be white. The closer one gets to the brain, however, the closer the electrical fluctuations approach $1/f$. The nervous system seems to act like a complex filtering device, screening out irrelevant elements and processing only the patterns of change that are useful for intelligent behavior.

The literature indicates there is no straight forward method of generating $1/f$ noise. However, Richard Voss, who has done much recent work with $1/f$ noise and its relationship to nature and music, provides the following procedure for synthesizing a sequence that is very close to $1/f$ noise. First, write down the binary numbers for the numbers 0 through 7 and assign three dice to the three columns of the binary numbers: die 1 for the left column, die 2 for the center column, and die 3 for the right column. Table 6.1 shows an example of this layout. The sum of the numbers on the three dice will range from 3 to 18. Mark off a horizontal axis on a piece of graph paper. Mark the vertical axis from 3 to 18. Start the process by throwing all three dice. The sum of the

TABLE 6.1 • Dice Arrangement for Generating $1/f$ Noise

Number	die-1	die-2	die-3
0	0	0	0
1	0	0	1
2	0	1	0
3	0	1	1
4	1	0	0
5	1	0	1
6	1	1	0
7	1	1	1

three dice is the first point of the sequence. The next point is determined by looking at Table 6.1. The difference between the binary number (000) and (001) is the (1) in the third column. For the next point in the sequence throw only die 3 because the only number that changed was in column three. The second point in the sequence is then the sum of all three dice even though only one die was thrown to produce a new value. For the third point the change in the binary numbers is from (001) to (010). In this case the numbers in both the last two columns changed, so throw die 2 and die 3 and add up all three dice to determine this value. Continue this process rotating through the eight binary numbers to determine which die to throw (Gardner, 1978). Figure 6.2 is a $1/f$ distribution produced with this method.

The reason this procedure comes close to producing a $1/f$ distribution is that die 1 changes only twice in the eight data points of a cycle; die 2 changes four times; die 3 changes at every data point. This provides a mix of stability and variability in the sum of the values of the dice.

Music

The idea that art imitates nature is found in even the earliest cultures and was clearly expressed in the philosophy of ancient Greece. With painting, sculpture, and theater this imitation is fairly obvious; with music it is less obvious. To be consistent with the other arts, music should imitate nature in some

FIGURE 6.2 • 1/f noise distribution. Adapted with permission from "Mathematical Games," Martin Gardner, *Scientific American*, April 1978.

FIGURE 6.3 • Synthetic music created with white noise (top), 1/f noise (middle), and brown noise (bottom). Adapted with permission from "Mathematical Games," Martin Gardner, *Scientific American*, April 1978.

fashion, but the Greeks could not find anything in nature that was like music. Plato, in *Laws*, Book II, states the following about music (Gardner, 1978):

> For when there are no words it is difficult to recognize the meaning of the harmony and rhythm, or to see that any worthy object is imitated by them.

Richard Voss studied a wide range of music including traditional music of Japan, classical ragas of India, folk songs of Russia, American blues, medieval music, Beethoven, Debussy, Strauss, and the Beatles. All these examples showed pitch fluctuations equivalent to $1/f$ noise. The music he studied also showed loudness fluctuations equivalent to $1/f$ noise (Barnsley et al., 1988). Voss has answered Plato's question about what music is imitating. Music imitates the way nature changes through time.

Synthetic Music

Music as a variation of tones in time can be synthesized using the three varieties of noise. White noise will produce a sequence of notes that jumps up and down too much to be a good model of real music. Brown noise generated music is too correlated. The low frequency fluctuations are too dominant in the resulting sequence of notes. $1/f$ noise, which is somewhere between the chaos of white noise and the high correlation of brown noise, produces a sequence of notes that begins to look like real music. Figure 6.3 shows three synthetic sequences of notes produced from white, $1/f$, and brown noise.

In an experiment, Voss created synthetic music by varying the melody and tone duration with white, brown and $1/f$ noise fluctuations. Tunes of these three kinds were played at universities for many people. The white music was too random, the brown music too correlated, and the $1/f$ music sounded almost like real music (Gardner, 1978). $1/f$ noise will not replace human composers of music. However, it might provide some aid or insight into the process of music composition.

Sheet Music as a Source of Fractal Distributions

Sheet music provides a ready source of fractal distributions for the designer without recourse to mathematical or computer manipulations. The distribution of notes up and down the scale is a $1/f$ noise distribution. The musical scale provides an easy to use datum for varying some feature of a design. For example, the width of a row of townhouses can be varied by picking a base width. Assign this width to a note on the music scale, then assign a variation, 2 feet for example, for each step up or down the scale. Once this pattern is set up, the sequence of notes on the sheet music can be used to provide a variation in townhouse width that is similar to the $1/f$ variation that nature presents to our senses.

Figure 6.6 shows a sequence of notes from "My Old Kentucky Home" divided in half, then divided in quarters, and finally divided into eighths. Measuring the average range between the high note and low note for time lags of 1/2 the sequence of notes, 1/4 the sequence of notes, and 1/8 the sequence of notes provides the information to estimate the fractal dimension of this sequence of notes observed in the chunk sizes shown.

FIGURE 6.4 • A sequence of notes from "My Old Kentucky Home" by Stephen Foster.

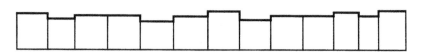

FIGURE 6.5 • The widths and heights of a row of townhouses varied with the use of sequences of notes from "My Old Kentucky Home."

FIGURE 6.6 • A sequence of notes from "My Old Kentucky Home" by Stephen Foster, broken in half, then in quarters, and finally in eighths so that the fractal dimension of the rhythm can be calculated with rescaled range analysis.

The range from high to low note in the two halves is 5 and 5 producing an average range of 5. The range from high to low note in the four quarters is 5, 2, 3, and 5 which produces an average range of 3.75. The range from high to low note in the eight eighths is 3, 2, 2, 1, 2, 3, 4, and 3 which produces an average range of 2.50. Two fractal dimensions can now be calculated.

At the larger scanning size, chunks of music with about 16 notes are compared to chunks of music with about 8 notes. First the Hurst exponent is calculated:

$$
\begin{aligned}
H\left(\frac{1}{2} - \frac{1}{4}\right) &= \frac{\left[\log(5) - \log(3.75)\right]}{\left[\log\left(\frac{1}{2}\right) - \log\left(\frac{1}{4}\right)\right]} \\
&= \frac{(0.699 - 0.574)}{(-0.301) - (-0.602)} \\
&= \frac{0.125}{0.301} \\
&= 0.415
\end{aligned}
$$

then the fractal dimension can be calculated since $D = 2 - H$.

$$
\begin{aligned}
D(16 \text{ notes} - 8 \text{ notes}) &= 2 - 0.42 \\
&= 1.58
\end{aligned}
$$

At the smaller scanning size chunks of music with about 8 notes are compared to chunks of music with about 4 notes:

$$
\begin{aligned}
H\left(\frac{1}{2} - \frac{1}{4}\right) &= \frac{\left[\log(3.75) - \log(2.5)\right]}{\left[\log\left(\frac{1}{4}\right) - \log\left(\frac{1}{8}\right)\right]} \\
&= \frac{(0.574 - 0.398)}{(-0.601) - (-0.902)} \\
&= \frac{0.176}{0.301} \\
&= 0.585
\end{aligned}
$$

since $D = 2 - H$

$$
D\,(8 \text{ notes} - 4 \text{ notes}) = 1.42
$$

These fractal dimensions tell us that this piece of music has slightly more surprise mixed into its order when looked at in 16 to 8 note chunks than when looked at in 8 to 4 note chunks.

Chapter 8 will present methods of using these complex rhythms in design compositions.

The Fractal Dimension of 1/f Noise

The fractal dimension, as defined in Chapter 3, and midpoint displacement, as a method of generating fractal distributions with different fractal dimensions, can be related to 1/f noise if the fractal dimension of 1/f noise can be estimated.

A straight line, with no variation in time, has a fractal dimension of 1. White noise, or random variation in time, has a fractal dimension that approaches 2. Brown noise has a fractal dimension in the neighborhood of 1.5. The fractal dimension of 1/f noise lies somewhere between the 1.5 fractal dimension of brown noise and the 2.0 fractal dimension of white noise.

The mix of order and surprise moves from all order in a straight line to all surprise in a white noise, neither of which is very interesting. The fractal dimension provides a calibration of the surprise that is mixed into the order of the noise fluctuation. The higher the fractal dimension, the more surprise is mixed into the underlying order. Martin Gardner expresses this concept in the following way:

> It is commonplace in musical criticism to say that we enjoy music because it offers a mixture of order and surprise. How could it be otherwise? Surprise would not be surprise if there were not sufficient order for us to anticipate what is likely to come next. Good music, like a person's life or the pageant of history, is a wondrous mixture of expectation and unanticipated turns. There is nothing new about this insight, but what Voss has done is to suggest a mathematical measure for the mixture.

In the final chapter of *An American Architecture,* "The Future of Organic Architecture," Frank Lloyd Wright gives advice to the young man in architecture:

> My father—a preacher and a minister—taught me to regard a symphony as an edifice of sound. And ever since, as I listen to Bach and Beethoven and Mozart, I have watched the builder build and learned many valuable things from music, another phase of understanding nature.

Frank Lloyd Wright was aware that music and nature had similar variability. His organic architecture taps this variability for inspiration.

Further Study

Choose a piece of sheet music and calculate the fractal dimension using rescaled range analysis.

Generate some sheet music using white noise, brown noise, and $1/f$ noise. Play the music on a piano.

Much of Alvar Aalto's work displays the complex rhythms of nature. Figure 6.7 is an elevation of Aalto's home and office. Note how the variation in window and wall panel size echoes the variability of tree spacing in the forest. Figure 6.8 is a fractal rhythm ($D = 1.7$) that you will learn to generate in Chapter 8. Note the similarity to tree spacing in a forest or to the spacing of precipitation days shown on Figure 7.1.

Chapter 8, "Fractal Records in Time," in *Fractals* by Jens Feder provides a good overview of the work of H. E. Hurst and the method of rescaled range analysis that he developed to study natural variations in time.

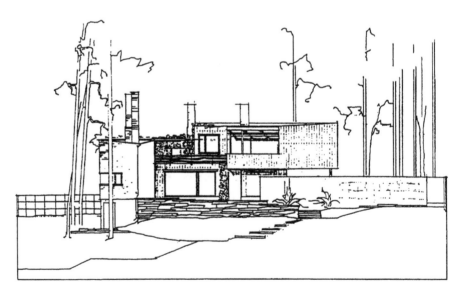

FIGURE 6.7 • An elevation of Aalto's home and office. Reproduced with permission from The Alvar Aalto Foundation, Helsinki, Finland.

FIGURE 6.8 • A fractal planning grid with only the vertical rhythm lines laid out. The rhythms in this figure are based on the $D = 1.7$ fractal rhythm set up in Figure 8.13.

7 | Fractal Concepts Applied to Architectural and Design Criticism

The Fractal Dimension in Architecture

Architectural forms are man-made and thus very much based in Euclidean geometry. However, in his book *The Fractal Geometry of Nature*, Mandelbrot makes the following comparison:

> The fractal new geometric art shows surprising kinship to Grand Master paintings or Beaux Arts architecture. An obvious reason is that classical visual arts, like fractals, involve very many scales of length and favor self similarity. Modern mathematics, music, painting, and architecture may seem to be related to one another. But this is a superficial impression, notably in the context of architecture. A Mies van der Rohe building is a scale bound throwback to Euclid, while a high period Beaux Arts building is rich in fractal aspects.

Mandelbrot is referring to the presence of a progression of interesting detail from the large to the small scale in the Beaux Arts buildings and a lack of this progression in modern buildings. Architectural history and theory make a

similar call for a progression of interest from the large to the small scale. Frank Lloyd Wright's buildings are a good example of this progression of self-similar detail from the large to the small scale.

The fractal dimension can be related to information theory as a measure of the mix between order and surprise. The higher the fractal dimension, the more surprise is mixed into the underlying order. Our senses evolved in the natural world, exposed to the fractal shapes of trees, clouds, stars, rivers, and weather cycles. Figure 7.1 shows the variation in temperature in 1992 in Baltimore, Maryland. Note the visual characteristics of the data. There is a clustered randomness to the temperature variation. There is a mix of order and surprise.

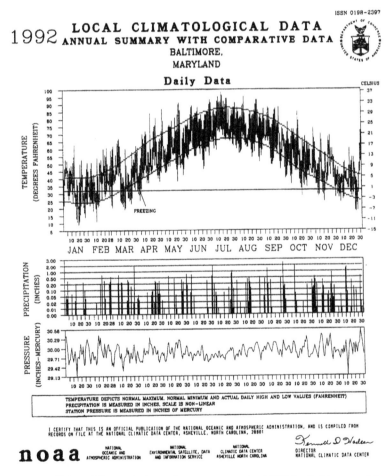

FIGURE 7.1 • The variation of temperature in 1992 in Baltimore, Maryland.

Buildings are not fractals in the same way that mathematical constructs such as the Koch curve are fractals. The Koch curve displays a progression of self-similar textural detail no matter how closely one looks at the curve. Figure 7.2 shows a view of Frank Lloyd Wright's Robie house. The roof line of the Robie house has self-similar textural characteristics but only through a limited range of scale. It eventually flattens into straight lines. But we do not experience architecture by zooming our attention in on a small section of the profile of the roof. We experience architecture by observing the overall profile of a building from a distance; as we approach closer, the patterns of window and siding come into attention; as we approach even closer, the details of doors and window frames come into attention, down to what the door knob is like. The process then continues inside the building. The fractal characteristic of an architectural composition presents itself in this progression of interesting detail as one approaches, enters, and uses a building.

Visual Perception and Fractal Range

In Chapter 3 various methods of determining the fractal dimension of natural shapes were presented. The important concept that there is an appropriate range of scales over which to take the measurements was also discussed. Mathematical constructs such as the Koch curve are the only true fractals, since they exhibit a growth in self-similar texture through an infinite range of scale change. Natural objects such as trees are only fractal-like. They display a self-similar growth in texture over a limited range. A tree's branching structure has from four to eight branchings from trunk to twigs.

FIGURE 7.2 • Frank Lloyd Wright's Robie house. FLLW drawings are Copyright © 1995 The Frank Lloyd Wright Foundation.

FIGURE 7.3 • Diagram of the incidence of rod and cone cells in the human eye.

The range of scales to use in the measurement of the fractal dimension of an architectural composition is also very important. The best place to look for an appropriate range of scales is found in the nature of visual perception. Figure 7.3 shows a diagram of the location of rod and cone cells in the human eye. We perceive detail in the center portion; the fovea and the macula.

The finest detail is observable only within the center 2 degrees, but significant detail can be observed through 10, 15, and 20 degrees (Helms, 1980). These angles can be related to the box-counting method grid size if we know how far away from a building the observer is standing. The measuring unit sizes that make sense for a given observer location can be determined using the following equation:

$$(\text{distance from the building}) \left[\tan(\text{angle})\right] = (\text{measuring unit size})$$

Table 7.1 shows measuring unit size related to angular incidence in the eye and the distance the observer is from the building. It is clear from the table that the range of scales that is appropriate for a person standing 40 or 80 feet away from a building is substantially different from the range of scales that is appropriate for a person standing close to a building and observing details.

One can test the scanning size ranges shown in Table 7.1 by standing 5 feet away from a painting that has large and small scale detail. Concentrate

TABLE 7.1 • Range of Scales Versus Angle Subtended in the Eye and Distance of the Observer from the Building

Angle at the Eye in degrees	Distance from the observers to the building				
	5′	10′	20′	40′	80′
2	2″	4″	8″	1.4′	2.8′
5	5″	10″	1.8′	3.5′	7.0′
10	10″	1.8′	3.5′	7.0′	14.1′
15	1.3′	2.7′	5.4′	10.7′	21.4′
20	1.8′	3.6′	7.3′	14.6′	29.1′

on the small scale detail and try to determine the size of the area you are looking at. Then look at a much larger area of the painting. The small scale detail fuzzes out of perception. Compare the size areas that you see clearly with the sizes listed in Table 7.1.

Using the Box-Counting Dimension

Frank Lloyd Wright's buildings provide good examples of a progression of interesting detail from large to small scale. From Table 7.1, the appropriate range of scales for a person observing the Robie house from 80 feet away, approximately across the street, ranges from 29.1 feet to 2.8 feet. A person on the sidewalk 20 feet from the building would have a scanning range from 7.3 feet to 8 inches. A person standing inside the building 5 feet from one of the stained glass windows would have a scanning range from 1.8 feet to 2 inches. Figure 7.4 shows elevations of the Robie house with grids drawn over them. The grid sizes range from approximately 24 feet to 12 feet, 6 feet, and 3 feet. This range corresponds to the range of sizes shown in Table 7.1 for a person observing the house from 80 feet away.

The box-counting dimension is calculated by counting the number of boxes that contain lines from the drawing inside them. As the grid size gets smaller, there will be more boxes that have lines in them. Table 7.2 relates the number of boxes that have lines in them to the number of boxes across the bottom of the grid, which indicates the grid size.

TABLE 7.2 • Box Count for the Robie House Elevations

box count	grid size	grid dimension
16	8	24 feet
50	16	12 feet
140	32	6 feet
380	64	3 feet

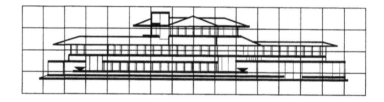

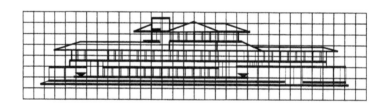

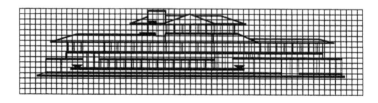

FIGURE 7.4 • Box-counting grids placed over elevations of the Robie house.

Three fractal dimensions can be calculated. The first is for the increase in number of boxes with lines in them from the grid with 8 boxes across the bottom (24 feet) to the grid with 16 boxes across the bottom (12 feet):

$$
\begin{aligned}
D_{(box,24'-12')} &= \frac{\left[\log(50) - \log(16)\right]}{\left[\log(16) - \log(8)\right]} \\
&= \frac{(1.699 - 1.204)}{(1.204 - 0.903)} \\
&= \frac{0.495}{0.301} \\
&= 1.645
\end{aligned}
$$

The next scanning range compares boxes that are 12 feet across with boxes that are 6 feet across:

$$
\begin{aligned}
D_{(box,12'-6')} &= \frac{\left[\log(140) - \log(50)\right]}{\left[\log(32) - \log(16)\right]} \\
&= \frac{(2.146 - 1.699)}{(1.505 - 1.204)} \\
&= \frac{0.447}{0.301} \\
&= 1.485
\end{aligned}
$$

The final scanning range compares boxes that are 6 feet across with boxes that are 3 feet across:

$$
\begin{aligned}
D_{(box,6'-3')} &= \frac{\left[\log(380) - \log(140)\right]}{\left[\log(64) - \log(32)\right]} \\
&= \frac{(2.580 - 2.146)}{(1.806 - 1.505)} \\
&= \frac{0.434}{0.301} \\
&= 1.441
\end{aligned}
$$

The final two calculations are in closer agreement than the first calculation. Look at the elevations with the grids drawn over them again. The largest grid is so large that every box in the grid contains lines from the elevation. The starting grid size should generally be small enough so that not all the boxes are

counted. Figure 7.5 shows the counted boxes shaded with a pencil. This is a good way to make counting a little easier. It also aids in understanding what the process actually measures. Boxes are left out of the count for two reasons: one, the profile of the building is described with greater accuracy, and two,

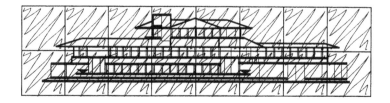

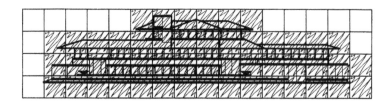

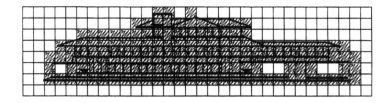

FIGURE 7.5 • The counted boxes from the box-counting analysis of the Robie house elevation.

blank or undetailed areas of the facade are indicated. Thus, the counted boxes represent the areas of the facade where there is something to look at.

The progression of shapes shown in Figure 7.5 has a distant relationship with the Sierpinski gasket. The Sierpinski gasket has a fixed rule that governs which pieces of the solid form are left out at each stage of its construction. The shaded boxes shown in Figure 7.5 have a more complex rule governing which areas of the solid shape are left out at each stage of the generation of

F I G U R E 7.6(a) • A 6 inch grid placed over one of the casement windows from the Robie house.

the form, but it is clear from looking at the figure that a rule of some sort applies. The rule is that the areas of the facade that are blank (without window mullions, cornices, or other detailing) are left out as the next stage of the form is generated.

The design interest of the Robie house does not stop at the 3 foot scanning range. Look back at Figure 7.5. The window mullion pattern has not affected the box count yet. In addition, there is even smaller detail to be seen as the observer comes closer.

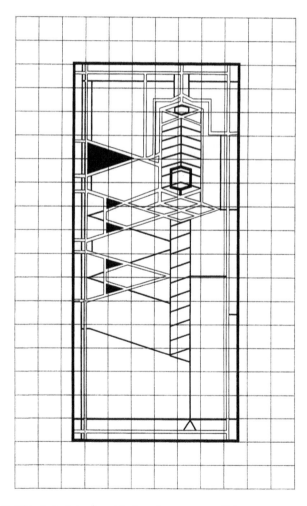

FIGURE 7.6(b) • A 3 inch grid placed over one of the casement windows from the Robie house.

Place yourself inside one of the rooms looking at one of the casement windows at a distance of about 5 feet. Table 7.1 suggests a grid range from 20 inches to 2 inches. The analysis of the elevation of the Robie house suggests that the larger grid sizes in this range do not provide much information, since all the boxes end up being counted. This suggests a grid range at the lower end of the range shown in Table 7.1. Figure 7.6 shows a casement window from the Robie house with grids of approximately 6 inches, 3 inches, and 1.5 inches. This figure is reproduced at a large enough scale so that the reader can count the boxes.

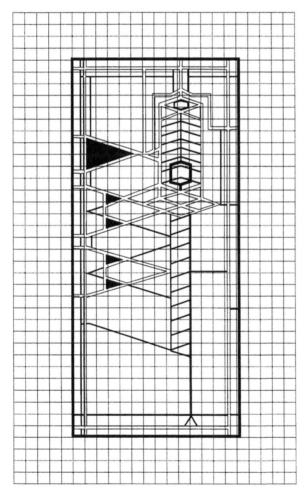

FIGURE 7.6(c) • A 1.5 inch grid placed over one of the casement windows from the Robie house.

TABLE 7.3 • Box Count for the Robie House Casement Window

box count	grid size	grid dimension
31	6	6 inches
102	12	3 inches
315	24	1.5 inches

The analysis of this window is an example of the use of the box-counting method in graphic design. The method aids in understanding whether a design has interest across multiple scales.

Table 7.3 relates the number of boxes that contain lines with the number of boxes across the bottom of the grid, which indicates the grid size. Note that the largest grid size, the 6 inch grid, has one box inside the figure of the window that is not counted. This box is the third column over and the third row up from the lower left hand corner. This is a good indication that the starting grid size is appropriate for the figure.

Two fractal dimensions can be calculated. The first is for the growth in number of boxes with lines in them from the grid with 6 boxes across the bottom (6 inches) to the grid with 12 boxes across the bottom (3 inches):

$$
\begin{aligned}
D_{(box;6''-3'')} &= \frac{\left[\log(102) - \log(31)\right]}{\left[\log(12) - \log(6)\right]} \\
&= \frac{(2.009 - 1.491)}{(1.079 - 0.778)} \\
&= \frac{0.518}{0.301} \\
&= 1.721
\end{aligned}
$$

Note that, since the grid size is cut in half from one grid to the next, the value of the denominator in the calculation of the box-counting dimension will always be 0.301.

The next scanning range compares boxes that are 3 inches across with boxes that are 1.5 inches across:

$$
\begin{aligned}
D_{(box,3''-1.5'')} &= \frac{\left[\log(315) - \log(102)\right]}{\left[\log(24) - \log(12)\right]} \\
&= \frac{(2.498 - 2.009)}{(0.301)} \\
&= \frac{0.489}{0.301} \\
&= 1.626
\end{aligned}
$$

The upper portion of the casement window has such small scale detailing that the grid size could probably be reduced two more times before exhausting the fractal growth in interest.

Consider what the fractal analysis of the building elevation and of a casement window of the Robie house has revealed. Frank Lloyd Wright had an amazing range of design implementation. The Robie house displays interesting form from a scanning range of 12 feet down to a scanning range of less than 1 inch. This represents a progression of observation from across the street to inside a room. The idea that Wright's designs have a progression of detail from large to small scale is not new. But, fractal analysis provides a quantifiable measure of the progression of detail.

Frank Lloyd Wright and Organic Architecture

Frank Lloyd Wright referred to his design method as organic. The term, however, has never been defined very precisely, even by Mr. Wright. He constantly refers to nature as a source of inspiration:

> Primarily, nature furnished the materials for architectural motifs out of which architectural forms as we know them today have been developed, and, although our practice for centuries has been for the most part to turn from her, seeking inspiration in books and adhering slavishly to dead formulae, her wealth of suggestion is inexhaustible; her riches greater than any man's desire.

Wright's writings tend to drift around the concept rather than to crisply define meaning. The statement above says that designers should look to natural forms for inspiration, but is not clear about how natural inspiration is translated into built form. The concept of fractal geometry and its relationship with natural forms did not exist when Wright was practicing architecture and writing about it. However, some of his writing approaches the concept very closely:

> The differentiation of a single, certain, simple form characterizes the expression of one building. Quite a different form may serve for another, but from one basic idea all the formal elements of design are in each case derived and held well together in scale and character. The form chosen may flare outward, opening flower like to the sky; another, droop to accentuate artistically the weight of the masses; another be noncommittal or abruptly emphatic, or its grammar may be deduced from some plant form that appealed to me, as certain properties in line and form of the sumac were used in the Lawrence house at Springfield; but in every case the motif is adhered to throughout so that it is not too much to say that each building aesthetically is cut from one piece of goods and consistently hangs together with an integrity impossible otherwise.

The last sentence in the above quote brings to mind images of fractals like the Julia sets. Julia sets display a wealth of detail at any level of magnification. This wealth of detail is the result of a very simple central concept, iteration.

The second sentence in the quote calls for all the elements of the design to be held together in "scale and character" by one basic idea. This brings to mind the simple rule systems that are used to generate fractal forms like the Koch curve that are at once very complex and very simple, since any small part is similar to the whole.

In the middle of the paragraph, Wright refers to the natural source of form generating ideas. He talks about the "line and form of the sumac." Wright clearly used nature for inspiration, but his buildings do not look like trees or bushes. He was looking beyond the outward appearance of the natural forms to the underlying structure of their organization. This is a fractal concept. Natural forms do have an underlying organizational structure, and fractal geometry provides a clear method of understanding and describing that structure.

One of the central features that fractal geometry tells us about nature is that nature is not flat. Nature displays an almost infinite number of scales of length. There is a never ending cascade of interesting form that comes in clusters and only rarely displays perfect symmetry. Fractal analysis of the Robie house showed that Wright designed the building with a cascade of detail from the organization of the building's masses to the stained glass designs of the windows.

A fractal analysis of Unity Temple should help explain Wright's ability to grasp the underlying structure of a natural form and translate it into building form. Wright enjoyed the way light filtered and slanted through the forest canopy on its way to the complex leaf covered ground (Hoffman, 1986). The skylights set in the complex interior beams of Unity Temple are an obvious result of Wright's enjoyment of light filtered from above. But what about the overall form of the building? The forest displays a form that is complex at the ground plane, simpler in the zone of the tree trunks, and complex again in the branching structure of the tree canopy. Figure 7.7 shows a sequence of grids placed over an elevation of Unity Temple.

The box-counting dimension for the elevation of Unity Temple is calculated as follows:

box count	grid size	grid dimension
39	10	15 feet
120	20	7.5 feet
335	40	3.75 feet

Two fractal dimensions can be calculated. The first is for the growth in number of boxes with lines in them from the grid with 10 boxes across the bottom (15 feet) to the grid with 20 boxes across the bottom (7.5 feet):

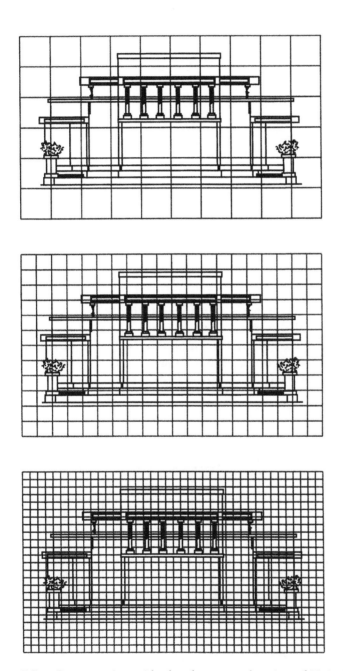

FIGURE 7.7 • Box-counting grids placed over an elevation of Unity Temple.

$$D_{(box,15'-7.5')} = \frac{\left[\log(120) - \log(39)\right]}{\left[\log(20) - \log(10)\right]}$$
$$= \frac{(2.079 - 1.591)}{(0.301)}$$
$$= \frac{0.488}{0.301}$$
$$= 1.621$$

The next scanning range compares boxes that are 7.5 feet across with boxes that are 3.75 feet across:

$$D_{(box,7.5'-3.7')} = \frac{\left[\log(335) - \log(120)\right]}{\left[\log(40) - \log(20)\right]}$$
$$= \frac{(2.525 - 2.079)}{(0.301)}$$
$$= \frac{0.446}{0.301}$$
$$= 1.482$$

These box-counting dimensions are very similar to those calculated for the Robie house. This indicates a similarity in the cascade of detail. To make the comparison to the forest canopy, it is necessary to divide the analysis of Unity Temple into three sections. Figure 7.8 shows the upper section; Figure 7.9 shows the middle; Figure 7.10 shows the bottom.

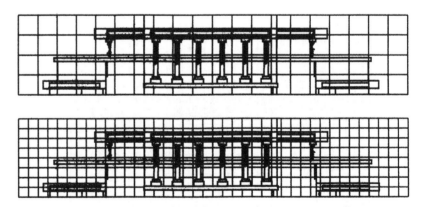

FIGURE 7.8 • A box-counting grid placed over the upper part of Unity Temple.

The box-counting dimension for the upper part of the elevation of Unity Temple is calculated as follows:

box count	grid size	grid dimension
57	20	7.5 feet
152	40	3.75 feet

$$D_{(box,7.5'-3.7')} = \frac{\left[\log(152) - \log(57)\right]}{\left[\log(40) - \log(20)\right]}$$
$$= \frac{(2.182 - 1.756)}{(0.301)}$$
$$= \frac{0.426}{0.301}$$
$$= 1.415$$

The box-counting dimension for the middle of the elevation of Unity Temple is calculated as follows:

box count	grid size	grid dimension
18	20	7.5 feet
42	40	3.75 feet

$$D_{(box,7.5'-3.7')} = \frac{\left[\log(42) - \log(18)\right]}{\left[\log(40) - \log(20)\right]}$$
$$= \frac{(1.623 - 1.255)}{(0.301)}$$
$$= \frac{0.368}{0.301}$$
$$= 1.223$$

FIGURE 7.9 • A box-counting grid placed over the middle of the elevation of Unity Temple.

FIGURE 7.10 • A box-counting grid placed over the base of Unity Temple.

The box-counting dimension for the base of the elevation of Unity Temple is calculated as follows:

box count	grid size	grid dimension
35	20	7.5 feet
112	40	3.75 feet

$$D_{(box,7.5'-3.7')} = \frac{\left[\log(112) - \log(35)\right]}{\left[\log(40) - \log(20)\right]}$$
$$= \frac{(2.049 - 1.544)}{(0.301)}$$
$$= \frac{0.505}{0.301}$$
$$= 1.678$$

The fractal dimensions as given by the box-counting dimensions of the top, middle, and base of Unity Temple are as expected for a design with forest imagery as a base idea. The upper part and base of the building have higher fractal dimensions than the middle of the building.

Frank Lloyd Wright believed that the ornament used on a building should be an integral part of the building:

> Integral ornament is the developed sense of the building as a whole, or the manifest abstract pattern of structure itself, interpreted. Integral ornament is simply structure-pattern made visible articulate and seen in the building as it is seen articulate in the structure of the trees or a lily of the fields.

Figure 7.11 shows the planter ornaments that are located on either side of the elevation of Unity Temple.

FIGURE 7.11 • The planters on either side of the elevation of Unity Temple with grids of 2 feet and 1 foot placed over them.

The box-counting dimension for the planters at Unity Temple is calculated as follows (the plants shown in the drawing were not included in this calculation):

box count	grid size	grid dimension
34	8	2 feet
85	16	1 foot

$$D_{(box,2'-1')} = \frac{\left[\log(85) - \log(34)\right]}{\left[\log(16) - \log(8)\right]}$$
$$= \frac{(1.929 - 1.531)}{(0.301)}$$
$$= \frac{0.398}{0.301}$$
$$= 1.322$$

This number is not complete, since the planting is not included. Wright considered the plant material part of the ornament of the building. His flower urns were given important places in his designs, since he knew that the form of his buildings and the plantings were in sympathy (Hoffman, 1986). Thus, the plants should be included in a calculation of the box-counting dimension for the planter.

The box-counting dimension for the planter and plantings at Unity Temple is calculated as follows (notice how nicely fractal-like Wright drew the plants):

box count	grid size	grid dimension
44	8	2 feet
130	16	1 foot

$$D_{(box,2'-1')} = \frac{\left[\log(130) - \log(44)\right]}{\left[\log(16) - \log(8)\right]}$$
$$= \frac{(2.114 - 1.643)}{(0.301)}$$
$$= \frac{0.471}{0.301}$$
$$= 1.565$$

Organic architecture emphasized the understanding of the deep principles underlying natural forms. One of these deep principles is a cascade of detail from the large to the small scale. Nature virtually never flattens out. The analysis of Unity Temple has shown that Wright provided a cascade of detail over a scanning range from 15 feet to 1 foot. Other detail on the building would take this cascade into the inch range.

FIGURE 7.12 • The top and base of the planter at Unity Temple with box grids of 2 feet and 1 foot placed over them.

To complete the analysis of the planter, it is necessary to look at the upper and lower part, as was done for the entire elevation of Unity Temple. Figure 7.12 shows the upper and lower parts of the planter with box grids.

The box-counting dimension for the top of the planter, including the plantings, at Unity Temple is calculated as follows:

box count	grid size	grid dimension
24	8	2 feet
84	16	1 foot

$$
\begin{aligned}
D_{(box,2'-1')} &= \frac{\left[\log(84) - \log(24)\right]}{\left[\log(16) - \log(8)\right]} \\
&= \frac{(1.924 - 1.380)}{(0.301)} \\
&= \frac{0.544}{0.301} \\
&= 1.807
\end{aligned}
$$

The box-counting dimension for the bottom of the planter at Unity Temple is calculated as follows:

box count	grid size	grid dimension
12	8	2 feet
25	16	1 foot

$$
\begin{aligned}
D_{(box,2'-1')} &= \frac{\left[\log(25) - \log(12)\right]}{\left[\log(16) - \log(6)\right]} \\
&= \frac{(1.398 - 1.079)}{(0.301)} \\
&= \frac{0.319}{0.301} \\
&= 1.060
\end{aligned}
$$

The results echo the results for the whole elevation. Note that the base is essentially just a few straight lines; the box-counting dimension of 1.06 tells us that there is very little cascade of interest. The base is a Euclidean entity.

I would like to end this discussion of Wright's concept of organic architecture with one final quote, in which Wright is giving advice to the young man in architecture:

You must read the book of nature. What we must know in organic architecture is not found in books. It is necessary to have recourse to Nature with a capital N in order to get an education. Necessary to learn from trees, flowers, shells—objects which contain truths of form following function. If we stopped there, then it would be merely imitation. But if we dig deep enough to read the principles upon which these are activated, we arrive at secrets of form related to purpose that would make of the tree a building and the building a tree.

When Wright refers to the principles on which the forms of nature are activated, he is calling for a fractal understanding of nature. He says that the student of architecture needs to learn from nature because there are no books that can teach the lessons of organic architecture. Directly observing nature is very important, but now there are books that can help the student understand "the principles upon which these (natural forms) are activated." A study of fractal geometry provides an awakening of observation abilities. Michael Barnsley in *Fractals Everywhere*, gives the following warning:

Fractal geometry will make you see everything differently. There is danger in reading further. You risk the loss of your childhood vision of clouds, forests, galaxies, leaves, feathers, flowers, rocks, mountains, torrents of water, carpets, bricks, and much else besides. Never again will your interpretation of these things be quite the same.

After studying fractal geometry the difference between an oak tree and a maple tree becomes clearer. The branching algorithm of the maple is different from that of the oak. Even the leaves echo this difference. The maple leaves are more ordered than the oak leaves, echoing the difference between the trees.

Le Corbusier and Purism

In 1917 Charles Edouard Jeanneret, later to become Le Corbusier, moved to Paris and met the artist Amedee Ozenfant. They shared a similar view of art that involved a desire to go beyond cubism, and developed a theory that was to be called purism (Baker, 1989). Geoffrey Baker, in *Le Corbusier: an Analysis of Form*, describes Purism in the following passage:

These ideas were first published in a book entitled *Après le Cubism*. Addressing themselves to what they regarded as the distinctive features of

the twentieth century, Ozenfant and Jeanneret set out to recognize those forces in life made manifest in science and the machine. They believed that machines and other man-made artifacts responded to the same laws of economy and selection through fitness of purpose that are apparent in nature. They were convinced that this was a universal principle, one of the results of which was a tendency toward harmony, order and balance in all things. They put forward the idea that art could enable man to establish contact with the universal force that governs existence.

Purism called for primary forms and colors, objects with significance beyond their immediate form, and geometry to organize the objects on the canvas. Their paintings used rhythms and tensions to express the governing forces of nature. One of Jeanneret's better compositions during this period is the painting *Nature Morte à la Pile D'assiettes*. It is a collection of objects ordered on the canvas. His work as a painter and his connection to purism led Le Corbusier to developed his ideas about composition (Baker, 1989).

Before using the box-counting method to look at Le Corbusier's architecture it would be helpful to look at his painting. Figure 7.13 is a drawing of Le Corbusier's painting *Nature Morte à la Pile D'assiettes* with box counting grids superimposed.

The box-counting dimension for Le Corbusier's painting *Nature Morte à la Pile D'assiettes* is calculated as follows:

box count	grid size	grid dimension
98	13	1/13 of image width
282	26	1/26 of image width
612	52	1/52 of image width

Two fractal dimensions can be calculated. The first is for a scanning range of 1/13 to 1/26 of the image width:

$$D_{[\text{box},(\frac{1}{13})-(\frac{1}{26})]} = \frac{\left[\log(282) - \log(98)\right]}{\left[\log(26) - \log(13)\right]}$$
$$= \frac{(2.450 - 1.991)}{(0.301)}$$
$$= \frac{0.459}{0.301}$$
$$= 1.525$$

FIGURE 7.13(a) • Le Corbusier's painting *Nature Morte à la Pile D'assiettes* with box counting grids placed over it.

FIGURE 7.13(b) • Le Corbusier's painting *Nature Morte à la Pile D'assiettes* with box counting grids placed over it.

The next scanning range is from 1/26 to 1/52 of the image width:

$$
\begin{aligned}
D_{[\text{box},(\frac{1}{26})-(\frac{1}{52})]} &= \frac{\left[\log(612) - \log(282)\right]}{\left[\log(52) - \log(26)\right]} \\
&= \frac{(2.787 - 2.450)}{(0.301)} \\
&= \frac{0.337}{0.301} \\
&= 1.119
\end{aligned}
$$

These are interesting results. At the larger scanning range the painting displays a fractal dimension that is similar to many natural forms, but at the smaller scanning range the fractal dimension approaches 1.0, indicating very little growth in interest at the smaller scale. This result is not surprising given that Le Corbusier took much of his inspiration from the modern machines of the beginning of the twentieth century. He makes reference to nature only in passing. It is clear that he was not observing nature's deep complex structures in the way that Frank Lloyd Wright observed them.

In 1929 Le Corbusier designed Villa Savoye, which is a culmination of his ideas of purism applied to building design. The house was a "machine for living" designed with primary forms organized in space with the guidance of

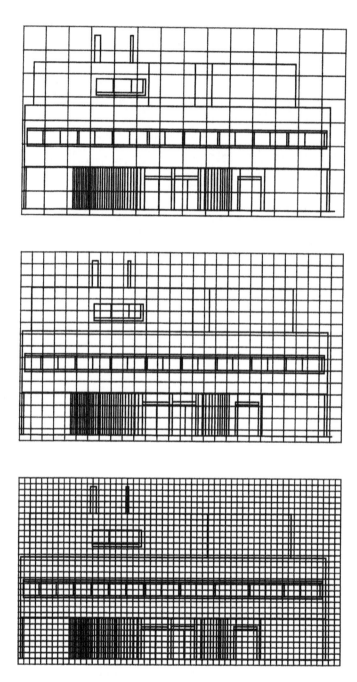

FIGURE 7.14 • The front elevation of the Villa Savoye with box-counting grids placed over it.

geometry. The villa is the geometry of man contrasted with the geometry of nature. It has many interesting features, but this analysis will look at the fractal characteristic of the front elevation. Figure 7.14 shows the front elevation of the Villa Savoye with box-counting grids superimposed.

The box-counting dimension for Le Corbusier's Villa Savoye is calculated as follows:

box count	grid size	grid dimension
100	14	8 feet
268	28	4 feet
675	56	2 feet

Two fractal dimensions can be calculated. The first is for a scanning range of 1/14 to 1/28 of the image width (note that the scanning ranges in relation to overall image size are almost the same as were used for Le Corbusier's painting):

$$
\begin{aligned}
D_{[\text{box},(\frac{1}{14})-(\frac{1}{28})]} &= \frac{\left[\log(268) - \log(100)\right]}{\left[\log(28) - \log(14)\right]} \\
&= \frac{(2.428 - 2.000)}{(0.301)} \\
&= \frac{0.428}{0.301} \\
&= 1.422
\end{aligned}
$$

The next scanning range is from 1/28 to 1/56 of the image width:

$$
\begin{aligned}
D_{[\text{box},(\frac{1}{28})-(\frac{1}{56})]} &= \frac{\left[\log(675) - \log(268)\right]}{\left[\log(56) - \log(28)\right]} \\
&= \frac{(2.829 - 2.428)}{(0.301)} \\
&= \frac{0.401}{0.301} \\
&= 1.333
\end{aligned}
$$

Le Corbusier has improved his ability to carry his compositional ideas across scales in the Villa Savoye as compared to his painting. The fractal dimension of the Villa Savoye does not flatten out as quickly as the fractal dimension of the painting *Nature Morte à la Pile D'assiettes*.

To make a complete comparison between Villa Savoye and the Robie house, it is necessary to take the box counting of Villa Savoye to a smaller

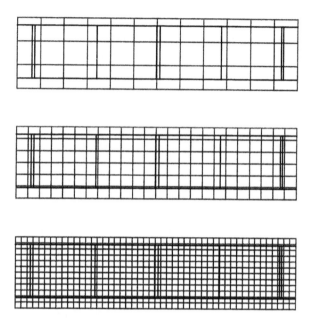

FIGURE 7.15 • Box-counting grids placed over a portion of the strip window of the Villa Savoye.

scale, as was done for the Robie house. Figure 7.15 shows part of the strip window with box-counting grids applied over it. The grid sizes range from approximately 2 feet to approximately 6 inches.

The box-counting dimension for a portion of the strip window of Le Corbusier's Villa Savoye is calculated as follows:

box count	grid size	grid dimension
29	12	2 feet
68	24	1 foot
136	48	6 inches

Two fractal dimensions can be calculated. The first is for a scanning range of 1/12 to 1/24 of the image width (note again that the scanning ranges in relation to overall image size are almost the same as were used for the painting and the overall elevation):

$$D_{[\text{box},(\frac{1}{12})-(\frac{1}{24})]} = \frac{\left[\log(68) - \log(29)\right]}{\left[\log(24) - \log(12)\right]}$$

$$= \frac{(1.833 - 1.426)}{(0.301)}$$

$$= \frac{0.371}{0.301}$$

$$= 1.233$$

The next scanning range is from 1/24 to 1/48 of the image width.

$$D_{[\text{box},(\frac{1}{24})-(\frac{1}{48})]} = \frac{\left[\log(136) - \log(68)\right]}{\left[\log(48) - \log(24)\right]}$$

$$= \frac{(2.134 - 1.833)}{(0.301)}$$

$$= \frac{0.301}{0.301}$$

$$= 1.000$$

At these smaller scales, where the box-counting dimension for the Robie house remained high, the dimension of Villa Savoye dropped off to 1.0, indicating a lack of progression of detail. This difference is due to the difference in design approach. Wright's organic architecture called for materials to be used in a way that captured nature's complexity and order. Le Corbusier's purism called for materials to be used in a more industrial way, always looking for efficiency and purity of use.

In the discussion of iterated function systems in Chapter 4, the process defined the product. The image that is initially fed into the iterative process has no effect. The different methods of Frank Lloyd Wright and Le Corbusier produce divergent results even though they both start with similar materials and similar programs.

The geometry that Le Corbusier used to organize his facades involved the use of a series of parallel and perpendicular lines to ensure that there would be a relationship between large and small elements. The use of these lines, as shown in the design for Ozenfant's studio in Figure 7.16, creates similarity transformations. In the second step, a diagonal is drawn across the top half of the design and labeled B1. In the next step the diagonal is shifted. The shifting is a translation. The diagonal is used to generate a window shape. Using the diagonal to generate the shape is a similarity transformation. The window rectangle is similar in shape to the upper half of the design. Using a line that is parallel

FIGURE 7.16 • Le Corbusier's layout of the front elevation of Ozenfant's studio. Reproduced with permission from *Le Corbusier: An Analysis of Form*, Geoffrey Baker, Chapman and Hall, 1989.

to line A1 (the diagonal through the whole design) to begin the subdivision of the window produces rectangles that are similar to the shape of the entire facade. The images of iterated function systems were created through the use of transformations similar to those Le Corbusier used.

Indigenous Buildings

Indigenous builders created settlements and buildings that fit very well into the character of the local environment. The process involves generations of time and a dependence on local materials. The composition of a row of houses in an

FIGURE 7.17 • A row of traditional houses in Amasya, Turkey.

indigenous town is one of clustered randomness. There is a complex cascade of rhythm and detail. This clustered randomness is also displayed in natural forms from mountains, forests, and trees to the clouds and stars in the sky. This clustered random cascade in nature has been shown to be fractal (Mandelbrot, 1983). It seems reasonable that the clustered random cascade of rhythm and detail seen in indigenous settlements and buildings may also be fractal.

To test this idea, a cluster of traditional housing in Amasya, Turkey, was studied (Bechhoefer and Bovill, 1994). The houses are clustered together at the base of a steep mountain ridge with a river running below them. Figure 7.17 is a sketch of a group of the houses, looking along the river. The houses date from the Ottoman period, but the building pattern was established as early as the third century B.C.

The box-counting method was applied to the mountain ridge behind the houses, Figure 7.18; to the site layout of the houses, Figure 7.19; and to the river elevation of a typical row of the houses, Figure 7.20. (Bechhoefer and Bovill, 1994).

The box-counting calculation method used in the previous examples was applied to the mountain ridge and to the site plan and elevations of the traditional housing built at the base of the mountain ridge. The box-counting dimension results are shown in Table 7.4, Table 7.5, and Table 7.6.

The fractal dimension of the traditional housing is very close to that of the mountain ridge, which is the dominant visual feature of the city of Amasya. This suggests that the indigenous builders somehow applied the rhythms of nature to their housing site layout and elevation design.

TABLE 7.4 • The Mountain Ridge, Box-Counting Dimensions

scale range	box-counting dimension
100–50 meters	1.63
50–25 meters	1.67
25–12.5 meters	1.40

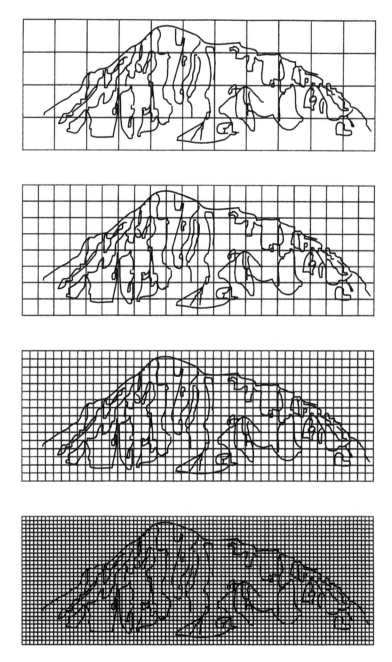

FIGURE 7.18 • Box-counting grids placed over the mountain ridge behind the traditional houses in Amasya, Turkey.

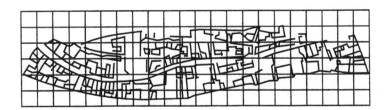

FIGURE 7.19 • Box-counting grids placed over the site layout of the traditional houses in Amasya, Turkey.

TABLE 7.5 • The Site Plan, Box-Counting Dimensions

scale range	box-counting dimension
50–25 meters	1.63
25–12.5 meters	1.70
12.5–6.25 meters	1.50
6.25–3.13 meters	1.23
3.13–1.56 meters	1.10

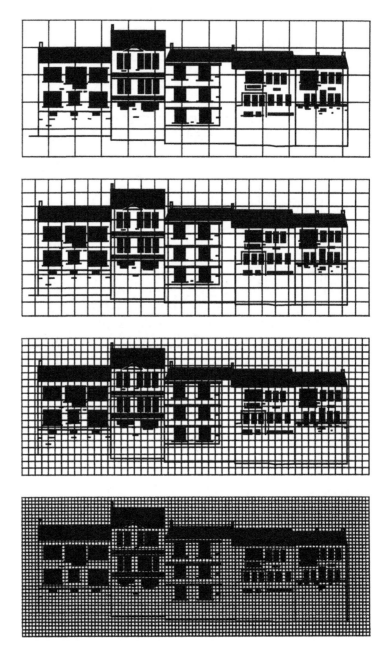

FIGURE 7.20 • Box-counting grids placed over the elevations of a typical row of traditional houses in Amasya, Turkey.

T A B L E 7.6 • The River Elevations, Box-Counting Dimensions

scale range	box-counting dimension
6–3 meters	1.67
3–1.5 meters	1.67
1.5–0.75 meters	1.70
0.75–0.38 meters	1.83

The fractal dimension for the site layout drops to 1.23 at the 6 meter scale range and to 1.10 at the 3 meter scale range. This indicates that the street layout of buildings loses progression of interest at the 6 to 3 meter scale range. At this scale range the cascade of interesting detail shifts away from the site layout to the detail on the elevations of the individual houses. On the elevations the cascade of detail continues down to 0.3 meters. At the larger scale ranges the layout of the street creates interest. At the smaller scales, the details on the elevations of the houses create interest. This cascade of interest progresses from 50 meters down to 0.38 meters. Modern housing seems to have lost the ability to create this cascade of interest.

Mondrian and Abstract Art

Representational art, because it reproduces nature in some fashion, displays a cascade of fractal detail because nature itself is a cascade of fractal detail. Piet Mondrian provides a good example of this. In his early paintings of natural scenes, exemplified by the *Woods Near Oele* (1908), there is a clear fractal rhythm to the spacing of the trees looking into the forest. Later in his life, during the 1920s, when he had moved toward abstract expression, his paintings became Euclidean in nature. Figure 7.21 shows *Painting I* (1926). Mondrian was interested in dynamic equilibrium, which he referred to as "equilibrated relationships" (Russell, 1981). The art and architecture of the times called for straight lines, right angles, and primary colors. Mondrian was after a "picture language which operated on its own, as a closed system, without any descriptive intention" (Russell, 1981). His abstract paintings from this period demonstrate this language, but they lack a cascade of interest.

When Mondrian moved to New York, his work progressed to a new level. He believed in a process of continuous evolution. In order to continue to annihilate static equilibrium, he moved away from the use of black lines of varying thickness to separate the colors on his paintings (Russell, 1981). In *The Meaning of Modern Art*, John Russell states:

FIGURE 7.21 • A diagram of *Painting I* (1926), Piet Mondrian.

Mondrian had quite other ideas, and at the end of his life he wanted to devise a more complex metaphor for the encounters, the misadventures and the mutual accomplishments of which life is made up. Once or twice he succeeded. Art exists, as we know, to negotiate with life on our behalf, and if possible to come to terms with it in ways that will help us live.

Figure 7.22 shows the rhythms of *Victory Boogie Woogie* (1944). This painting comes close to achieving the complex metaphor of life that Mondrian desired. It displays the dynamic equilibrium of his earlier abstract paintings, but it also has the cascade of interest that is present in our lives and in all of nature around us.

Figure 7.22 shows only the form rhythms of *Victory Boogie Woogie*. There are also color rhythms. Simplifying the color use to red, blue , yellow, black, and gray, the following sequence was recorded from one of the bands across the painting:

$$y, gr, r, y, gr, y, blk, b, y, y, blk, b, y, blk, y, r, y, blk, y, blk$$

where y = yellow
 r = red
 b = blue
 gr = gray
 blk = black

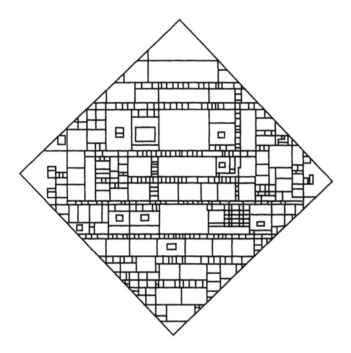

FIGURE 7.22 • A diagram of *Victory Boogie Woogie* (1944), Piet Mondrian.

If an order is given to these colors, a plot can be produced that is similar to the noise and music plots that were discussed in Chapter 5. We can use an order derived from the color wheel with black and gray added at the end. The order is as follows:

$$red = 1$$
$$blue = 2$$
$$yellow = 3$$
$$black = 4$$
$$gray = 5$$

Using this ordered scale, the color sequence listed above for one of the bands across *Victory Boogie Woogie* is as follows:

$$1, 5, 1, 3, 5, 3, 4, 2, 3, 3, 4, 2, 3, 4, 3, 1, 3, 4, 3, 4$$

This sequence can then be plotted to see what it looks like as a noise. Figure 7.23 is a plot of this sequence.

An alternative method of organizing the colors is by value. The order is as follows:

FIGURE 7.23 • A noise plot of the colors used across one of the bands of *Victory Boogie Woogie* using the color wheel as an organizer of the colors.

yellow = 1
gray = 2
blue = 3
red = 4
black = 5

This ordering by value produces the following noise sequence:

$$1, 2, 4, 1, 2, 1, 5, 3, 1, 1, 5, 3, 1, 5, 1, 4, 1, 5, 1, 5$$

Figure 7.24 shows a noise plot of this sequence.

The noise plot of the colors organized by value jumps up and down wildly like random noise, while that organized by the color wheel shows a better mix of order and surprise. It displays the character of sheet music to a greater degree than the value-based plot. This could be interpreted as an indication that Mondrian sequenced from color theory rather than value relationships. Another way to look at this comparison is that the color-organized plot is more complex from an information standpoint than the value-organized plot. Remember that in Mondrian's own words he was looking for "a more

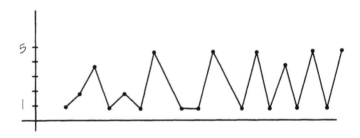

FIGURE 7.24 • A noise plot of the colors used across one of the bands of *Victory Boogie Woogie* using value as an organizer of the colors.

complex metaphor for the encounters, the misadventures and the mutual accomplishments of which life is made up" (Russell, 1981). Chapter 6 explained the relationship between the variability seen in music and that seen in natural changes over time. From Mondrian's statement, this kind of variability would be expected in his work.

Over the last ten years a fractal generated art has emerged. In *The Fractal Geometry of Nature*, Mandelbrot compares computer generated fractal art with traditional and abstract art in the following comment:

> The fractal new geometric art shows surprising kinship to Grand Masters paintings or Beaux Arts architecture. An obvious reason is that classical visual arts, like fractals, involve very many scales of length and value self similarity. For all these reasons, and because it came in through an effort to imitate Nature in order to guess its laws, it may well be that fractal art is readily accepted because it is not truly unfamiliar. Abstract paintings vary on this account: those I like also tend to be close to fractal geometric art, but many are closer to standard geometric art—too close for my own comfort and enjoyment.

Figure 7.25 is an example of the fractal art that Mandelbrot is referring to. It is from the dedication page of *The Fractal Geometry of Nature*. This book contains many examples of this kind of image. Julia sets, as discussed in Chapter 4, are another example of fractal art.

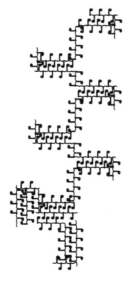

FIGURE 7.25 • Fractal art from the dedication page of *The Fractal Geometry of Nature*. Reprinted with permission from Benoit Mandelbrot.

Further Study

Figure 7.26 is a comparison of Romanesque windows. Note how the texture at the top of the windows increases through windows A, B, C, D, and E. Also note how the jump in texture from the main body of the window to the top is less pronounced in window M than it is in window J. Look through design and architecture books for examples of control over textural depth. Is there self-similarity present?

Fractals by Hastings and Sugihara provides examples of the use of fractal analysis in the natural sciences. Some of the natural variations studied are earthquake patterns, ocean temperature fluctuations, and ecosystem stability. Fractal classification of ecosystems and natural variations should prove helpful in designing man made structures that are in sympathy with natural variability while providing for human needs and comfort. Green architecture needs an image that reflects its purpose.

Look through *Twentieth Century Style and Design* by Bayley, Garner, and Sudjic. In architecture and in the decorative arts there is considerable cascade of shape and detail. There is less of a cascade of detail in industrial design which should be expected since physical function is more dominant in industrial design.

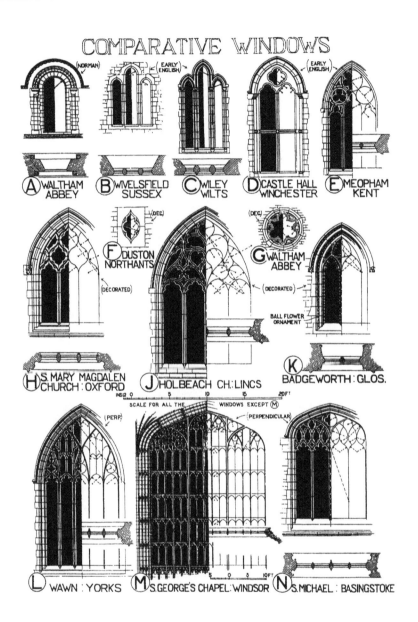

COMPARATIVE WINDOWS

A WALTHAM ABBEY (NORMAN)

B WIVELSFIELD SUSSEX (EARLY ENGLISH)

C WILEY WILTS

D CASTLE HALL WINCHESTER

E MEOPHAM KENT (EARLY ENGLISH)

F DUSTON NORTHANTS (DEC)

G WALTHAM ABBEY (DEC)

H S. MARY MAGDALEN CHURCH : OXFORD (DECORATED)

J HOLBEACH CH : LINCS

K BADGEWORTH : GLOS. (DECORATED) BALL FLOWER ORNAMENT

INS12 0 5 10 15 20FT
SCALE FOR ALL THE WINDOWS EXCEPT (M)

L WAWN : YORKS (PERP)

M S. GEORGE'S CHAPEL : WINDSOR (PERPENDICULAR)

N S. MICHAEL : BASINGSTOKE

0 5 10FT

FIGURE 7.26 • A comparison of Romanesque windows. Reproduced with permission from The British Architectural Library, RIBA, London.

8 | Fractal Concepts Applied to Design

Generating Fractal Rhythms with Sheet Music

Chapter 6 established the relationship between the fractal character of nature's changes through time and the fractal character of music. Thus, sheet music provides fractal distributions that are easy to obtain and use. Figure 8.1 is a line of musical notes from "My Old Kentucky Home."

Sheet music provides fractal distributions that are preorganized along datum lines. The musical scale provides a discrete set of datum lines, and the notes provide discrete positions up and down the datum. The best way to describe the use of sheet music as a fractal distribution is through a simple example.

FIGURE 8.1 • A line of musical notes from "My Old Kentucky Home."

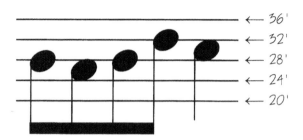

FIGURE 8.2 • Building height related to a musical scale.

To design a row of buildings, such as townhouses or a commercial street of stores with a variability that is similar to nature, start with a basic size and a modular amount that the size can change. As an example start with 28 feet as the basic size and 2 feet as the modular amount. Relate these values to the sheet music, as demonstrated in Figure 8.2. The numbers on the right represent the height of the individual buildings.

A sequence of building heights can be determined by the placement of the notes on the scale. Applying the scale from Figure 8.2 to the line of sheet music in Figure 8.1 produces the following sequence of building heights:

$$28, 26, 28, 32, 30, 22, 24, 26, 26, 24, 22, 26, 24$$

Figure 8.3 shows a massing layout for a group of buildings using the above method. The heights of the buildings are as given in Figure 8.2. A different sequence of notes was used to determine the widths of the buildings, the front setbacks, and the rear setbacks. The result is a complex rhythm structure that is similar to the rhythm displayed by nature. It is also similar to the rhythms displayed in indigenous building layouts.

The traditional areas of our older cities such as Annapolis, Maryland display a similar complex rhythm structure. In Annapolis, this structure is the result of how the land was subdivided. Initially, land was given out in large blocks to a few people. These people then haphazardly broke off pieces for a building here and a house there. The process is somewhat similar to the curdling process discussed in Chapter 4, except that more than one area is being subdivided at the same time and the subdivisions are not all the same size.

Sheet music can also be used to provide a fractal distribution of details on a sequence of buildings. Figure 8.4 shows a musical scale related to a vocabulary of details for the panel below a bay window. A row of new Victorian facades can thus recapture the magic created by different builders choosing from a vocabulary of details over an extended period of time.

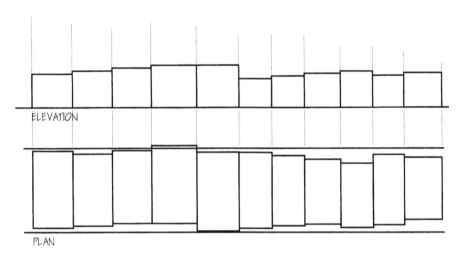

FIGURE 8.3 • A fractal layout of a group of buildings in elevation and plan using sheet music from "My Old Kentucky Home" as the source of fractal variation.

FIGURE 8.4 • A musical scale related to a vocabulary of details.

Generating Fractal Rhythms
with Midpoint Displacement

Midpoint displacement was introduced in Chapter 5. It is often used to design fractal landscapes. One advantage midpoint displacement has over music as a generator of fractal rhythms is that the fractal dimension of the distribution can be adjusted. Thus, the fractal dimension of a mountain ridge behind a site can be used as a generator of the rhythms used in the design of the project. Another advantage is that midpoint displacement can be implemented on a computer and linked to a computer aided drawing program to produce a design tool that requires only a conceptual knowledge of fractal concepts. This computer system could be thought of as an automatic rhythm generator. It would still be up to the designer to choose which rhythm to use, in the same way that a designer selects from several early sketches of a design. Figure 8.5 is a plot of two fractal distributions produced with the algorithm `MidPointFMID` (Barnsley et al., 1988). The upper curve has a fractal dimension of 1.7, and the lower curve has a fractal dimension of 1.3.

One problem with midpoint displacement is that the plot of the fractal distribution is a continuous line. When one applies a scale to a curve, the values will not be modular. In Chapter 5 these fractal curves were translated into

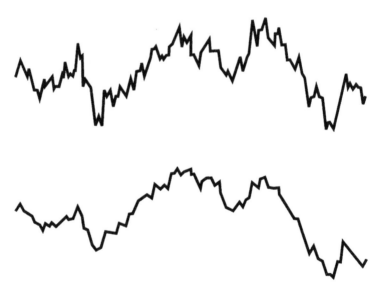

FIGURE 8.5 • Fractal curves produced with the algorithm `MidPointFMID` (Barnsley et al., 1988). The upper curve has a fractal dimension of 1.7 and the lower curve has a fractal dimension of 1.3. Reproduced with permission from *The Science of Fractal Images*; Barnsley, Devaney, Mandelbrot, Peitgen, Saupe, and Voss; Springer-Verlag; 1988.

step functions that produce modular values. Figure 8.6 reproduces the scale of vertical and horizontal lines that were superimposed on the fractal curves to resolve them into step functions. Figure 8.7 reproduces the resulting fractal step functions.

To show how this information can be used, a sequence of window mullions will be laid out for a strip window based on data from each of the curves. The sequence of modular values from the fractal distribution with $D = 1.7$ is as follows.

$$2, 1, -2, 0, -1, 1, 3, -1, -5, -2, -3$$

The base width of the window is arbitrarily set at $4'\ 4''$. From this base a value of $4''$ times the sequence of numbers above will be added or subtracted from the base window width. The resulting sequence of window widths is as follows:

$$5', 4'\ 8'', 3'\ 8'', 4'\ 4'', 4', 4'\ 8'', 5'\ 4'', 4', 2'\ 8'', 3'\ 8'', 3'\ 4''$$

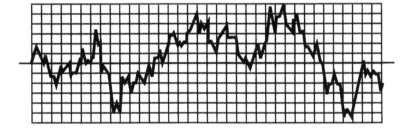

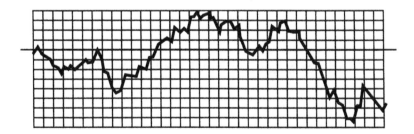

FIGURE 8.6 • A horizontal and vertical scale applied over the fractal distributions. The upper curve has a fractal dimension of 1.7. The lower curve has a fractal dimension of 1.3.

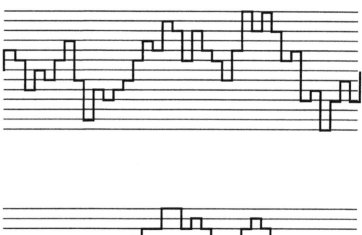

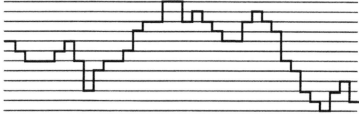

FIGURE 8.7 • Fractal curves resolved into step functions. The upper curve has a fractal dimension of 1.7 and the lower curve has a fractal dimension of 1.3.

A similar sequence of widths is developed below for the fractal distribution with $D = 1.3$:

$$0, -1, -2, -2, -2, -1, 0, -2, -5, -3, -2$$
$$4'\ 4'', 4', 3'\ 8'', 3'\ 8'', 3'\ 8'', 4', 4'\ 4'', 3'\ 8'', 2'\ 8'', 3'\ 4'', 3'\ 8''$$

Figure 8.8 is a drawing of the mullion layout for a strip window using the above fractal generated rhythm. The upper window uses the first set of values, the lower window uses the second. There is a noticeable difference between the two, but the difference is not visually great. This is the result of the 4″ step amount. Using a larger step amount would create a more noticeable variation.

Using a Modular Scale with Midpoint Displacement

The visual difference between the two versions of strip windows in Figure 8.8 was not very great. The 4″ step did not produce a large enough variation. An important question is, what step amount will produce the most noticeable variation between fractal generated rhythms? The answer is to use a different method. To produce optimal variation between fractal generated rhythms, it would be ideal to have a modular scale of sizes that were based on our ability to

FIGURE 8.8 • Strip windows with fractal assisted mullion layouts. The upper window is derived from the $(D = 1.7)$ values. The lower window is derived from the $(D = 1.3)$ values.

distinguish size difference. Luckily, such a scale exists. Dom H. Van Der Laan has researched this problem and produced a scale based on human ability to perceive size differences. The scale is published in his book *Architectonic Space*. The scale was based on experiments in which people separated cards of different sizes into groups. Figure 8.9 shows the scale and the names Van Der Laan gives to the eight measure scale.

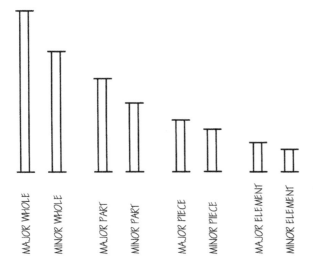

FIGURE 8.9 • Van Der Laan's architectonic scale.

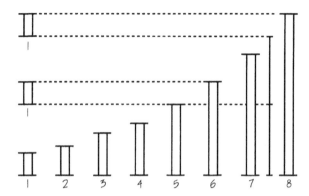

FIGURE 8.10 • The relationship between the smallest and largest members of the scale of eight measures.

The scale has the following characteristics. If one looks at any four measures in a row, the first two measures add up to the fourth measure. Look at the largest four measures. The major part and the minor part add up to the major whole. The minor whole is not small enough to be a major part and not big enough to be a major whole. Thus, it is a minor whole. Figure 8.10 shows another feature of the scale. There are eight measures in the scale because this is the largest range that retains a relationship between the smallest element of the scale and the largest. The smallest element of the scale is also the size difference between the major whole and the minor whole. Finally, the smallest element in the scale can act as the largest element in an eight measure scale that descends to smaller sizes, and the largest element in the scale can be used as the smallest element in a larger scale of eight measures.

The size ratios that define the scale are as follows.

major whole	7
minor whole	5 1/4
major part	4
minor part	3
major piece	2 1/4
minor piece	1 3/4
major element	1 1/4
minor element	1

Figure 8.11 shows a square as the largest element in a sequence of sizes. The widths are then reduced by the ratios of the Van Der Laan scale to produce a sequence of sizes. These widths can be used in the generation of fractal rhythms. The smallest width will be 1, and the largest width will be 7.

FIGURE 8.11 • Sequence of modular sizes to be used for developing fractal rhythms. The widths are based on the Van Der Laan scale.

Figure 8.12 shows the fractal distributions used earlier. The upper curve has a fractal dimension of 1.7, and the lower curve 1.3. The curves have been resolved into discrete jumps.

The vertical break through both curves indicates where the sequence of values will begin. The values are as follows:

for $D = 1.7$ $1, 3, 5, 4, 7, 6, 3, 6, 4, 3, 1, 4, 8, 6, 8, 6$
for $D = 1.3$ $1, 3, 4, 4, 6, 6, 4, 5, 4, 3, 2, 2, 4, 5, 4, 3$

Using the scale of widths shown in Figure 8.11 and the fractal distributions listed above, the following fractal distribution of mullions along a strip window can be generated. The difference between the rhythms is now more clearly seen, since the Van Der Laan modular scale maximizes the visual jumps.

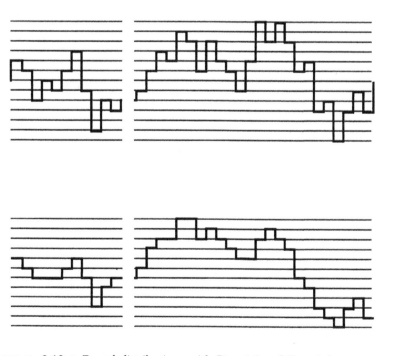

FIGURE 8.12 • Fractal distributions with D = 1.7 and D = 1.3.

F I G U R E 8.13 • Strip windows with fractal assisted mullion layouts using the Van Der Laan modular scale. The upper window is derived from the ($D = 1.7$) values, the lower window from the ($D = 1.3$) values.

The use of a modular scale allows fractal rhythms to be used in planning the layout of a building. As an example, modular widths can be coordinated with the widths of pans used to lay out concrete joists. They would produce a natural rhythm throughout the building. The rhythm generated for $D = 1.3$ in Figure 8.13 would work better than that generated for $D = 1.7$ for an exposed concrete joist layout, because there is less variation between joist spacing, thus the structural detailing problems would be minimized. The rhythm of the joist layout and the variation in room sizes would capture the variability of nature.

The use of variation within a modular group of sizes seems like a natural opportunity for the precast concrete industry. From a limited number of piece sizes an infinite variety of designs can be produced.

Figure 8.14 is a sketch of part of the elevation of Finnish architect Reima Pietila's student club at Otaniemi. The window mullion rhythm has the fractal characteristics that were explored in Figure 8.13. Pietila took his inspiration from nature. It is not surprising that there are fractal rhythms in his building. In *Arquitectura Finlandesa*, Maria Borras states:

> His Dipoli at Otaniemi, the students' club which they helped to build and which belongs to them alone, shuns classicism and formal perfection, and is so built as to live in osmosis with the land from which it grew, hardly visible from the air, for its roof blends with the surrounding countryside. If anyone enters Dipoli expecting to walk along corridors and halls of more or less regular construction, he is likely to feel giddy. You have to en-

FIGURE 8.14 • A sketch of part of the elevation of Finnish architect Reima Pietila's student club at Otaniemi.

ter Dipoli as you would a forest or a slice of Finnish landscape, something which does not conform to any geometry. If the big windows follow any symmetry, it is that of tree trunks; the walls, that of the rocks that support them; the morphology, that of a gigantic mushroom wise enough to stay close to the ground.

Pietila's student center goes beyond fractal rhythms in the windows. The fractal rhythms of nature penetrate throughout the design of the building.

Fractal Rhythms in Planning Grids

Planning grids are helpful in the coordination of the layout of a building, a painting, or a graphic design. Traditionally these grids are Euclidean. Figure 8.15 shows the grid of lines that coordinates the layout of Palladio's Villa Rotunda. The rhythms set up by the lines are symmetrical in two directions.

Fractal rhythms can be used to produce planning grids that utilize the rhythms of nature as a source of layout inspiration. Figure 8.16 shows a fractal planning grid using the fractal distribution generated for $D = 1.7$ in Figure 8.13. The same fractal rhythm was used for the horizontal and the vertical rhythms. Figure 8.17 shows the plan of Frank Lloyd Wright's Willits house with a planning grid generated from the layout of the major plan elements.

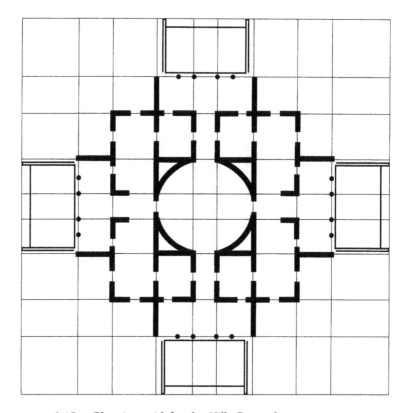

FIGURE 8.15 • Planning grid for the Villa Rotunda.

FIGURE 8.16 • Fractal planning grid based on the fractal rhythm set up in Figure 8.13 with a fractal dimension of 1.7.

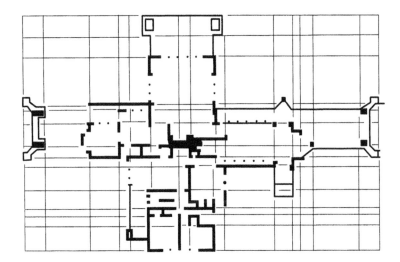

FIGURE 8.17 • A planning grid based on the major plan elements of Frank Lloyd Wright's Willits House.

Compare the grids in Figures 8.15, 8.16, and 8.17. Frank Lloyd Wright clearly did not use a strict Euclidean grid like the one used for the Villa Rotunda. His layout is more natural, more fractal.

Figure 8.18 is a fractal planning grid with only the vertical rhythm lines laid out. Again, this is based on the $D = 1.7$ fractal rhythm set up in Figure 8.13. This rhythm produces a very interesting image all by itself. Figures 8.19 and 8.20 show in outline the Edvard Munch paintings *The Voice* and *The Dance of Life*. A vertical planning grid has been overlaid on these images based on their prominent features. Munch clearly understood the complexities of nature's fractal rhythms.

Figure 8.21 shows a scale of vertical planning lines. Eleven lines are distributed inside each square so that the visual density would be equal. The square on the left, with equal spacing between lines, represents a fractal dimension of 1.0. The square in the middle was generated from a fractal distribution with $D = 1.3$. The square on the right was generated from a fractal distribution with $D = 1.7$. Visual diversity builds from left to right as the fractal dimension increases. This suggests that fractal planning lines may be helpful in controlling the range of contrast between order and surprise displayed in a graphic design. A graphic scale of increasing fractal dimension can also be used to visually estimate the fractal dimension of the rhythms used by painters like Munch.

FIGURE 8.18 • A fractal planning grid with only the vertical rhythm lines laid out. The rhythms in this figure are based on the $D = 1.7$ fractal rhythm set up in Figure 8.13.

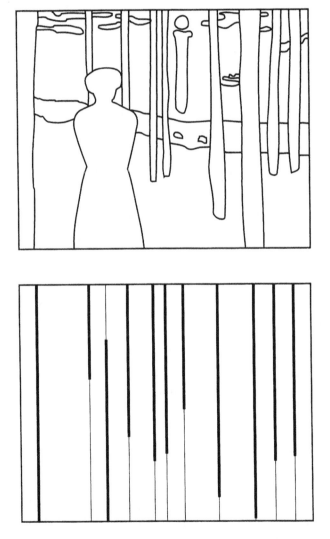

FIGURE 8.19 • A diagram of Edvard Munch's painting *The Voice* with a vertical planning grid overlaid on the image.

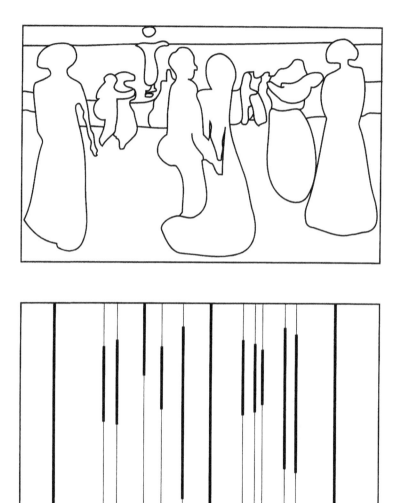

FIGURE 8.20 • A diagram of Edvard Munch's painting *The Dance of Life* with a vertical planning grid overlaid on the image.

FIGURE 8.21 • Three fractal planning grid layouts based on fractal distributions of $D = 1.0$, $D = 1.3$, and $D = 1.7$.

Nature's Fractal Order

In *The Dynamics of Architectural Form*, Rudolf Arnheim discusses order and disorder. In this discussion he refers to the "noise qualities of natural behavior" and states that "to imitate such an effect deliberately would be ludicrous." *The Dynamics of Architectural Form* was published in 1977 the same year that Mandelbrot first published *The Fractal Geometry of Nature*. What Arnheim refers to as the noise of nature Mandelbrot saw as an exquisite cascade of self-similar order. The concept of the boundary between order and disorder has been changed by Mandelbrot's fractal geometry. Arnheim goes on to quote Portoghesi:

> Modern architecture has discovered the fascination of spontaneous compositions, or architecture without architects, and of the unrepeatable harmony that comes about when similar units produced by different hands at different times are placed next to one another. Once this type of beauty, created by time and by the sediment left from generation to generation, had been discovered and celebrated in the literature, one tried naively to capture it and to replicate it in the laboratory by vaguely imitating its form, without understanding that a form born from a process cannot be retrieved without the process sustaining it.

Fractal geometry provides a means to tap the process. The complex rhythms that are present in traditional settlements can be reproduced with the aid of fractal geometry. The designer is not copying the particular indigenous layout but rather using the underlying rhythmic structure that makes the settlement pleasant, the same rhythmic structure that makes nature pleasant.

Further on in his chapter on order and disorder Arnheim gets to the heart of the issue:

> What is meant by disorder? Not simply the maximum absence of order. I mentioned earlier that as structural articulation is reduced, components become interchangeable and the prevailing texture homogeneous. I also said that, contrary to the terminology of physicists, such homogeneity needs to be considered a state of order, even though at a very simple level. Disorder is something else. It is brought about by discord between partial orders, by the lack of orderly relations between them. The relations existing in a disorderly situation could equally well be some other way; they are purely accidental. An orderly arrangement is governed by an overall principle; a disorderly one is not.
>
> However, the components of a disorderly arrangement must be orderly within themselves, or the lack of controlled relations between them would disrupt nothing, frustrate nobody. You cannot sabotage a melody unless there is one, and one melody cannot be incompatible with another unless each of them possesses a structure of its own. I therefore define disorder as a clash of uncoordinated orders.

FIGURE 8.22 • A sketch of the noise abatement walls along Highway 50 west of Annapolis, Maryland.

Nature is not noise. It is not homogeneous chaos. Nature is ordered in a self-similar clustered cascade of fractal rhythms. Buildings and works of art do not have to tap into this new knowledge, but it should not be excluded by prefractal ideas of order. The key is found in the last sentence of the previous quote. Disorder is caused when different order systems clash with one another.

There is a clear example of this principle on Highway 50 just west of Annapolis, Maryland. Highway 50 is a six lane freeway. Noise abatement walls of precast concrete have been installed on either side of the freeway. The forest behind the walls rises above the walls creating a clash of uncoordinated orders. The Euclidean brutality of the noise abatement wall clashes with the fractal rhythms of the treetops seen beyond the wall. Figure 8.22 is a sketch of the as-built situation.

This is a clear case where fractal rhythms can be of use. The fractal dimension of the treetops is typically close to 1.3. The fractal distributions from Figure 8.7 can be used to vary the heights and widths of the precast concrete pieces that make up the noise abatement wall. The resulting wall would have a rhythmic structure, an order, that is similar to the rhythmic structure of the treetops that are seen beyond the wall.

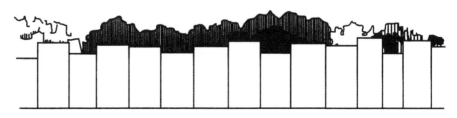

FIGURE 8.23 • Fractal design for a noise abatement wall with trees behind it.

Deconstruction

Deconstruction as a philosophy asserts that streams of text or works of art are open to the interpretation of the reader or observer. There is no absolute connection between words and meanings (Winograd and Flores, 1986).

This is a result of the fact that the structure of memory is fractal (Rucker, 1987). Consider a word like "sailboat." In my memory structure the word "sailboat" fires up a complex net of images that go back through the many sailboats that my father owned to the *El Toro* I sailed on Lake Merced in San Francisco during grammar school. All these memories connect to events that happened and people who were present on sailing excursions, which then connect to all kinds of other thoughts. The word "sailboat" does not point to an abstract image of a boat with a sail. It fires up a complex set of mental interconnections that are hard to draw a boundary around. The interconnections and the boundary around them are infinitely complex like a Julia set.

In a simple sentence, the fact that my fractal net for the word "sailboat" is different from another person's is not too important. The fractal nets have enough similar features for us to communicate. Yet, even in a simple sentence there is a fuzziness to the communication. As sentences become paragraphs, chapters, and books, exact communication becomes more of a problem. Everyone will interpret the meaning slightly differently because the fractal nets that the words fire up in their memories are slightly different.

Bernard Tschumi is an architect who has been a leader in the deconstruction movement in architecture. The Parc de la Villette in Paris is a built example of his ideas. Tschumi's design for this park was the winning entry in an international competition. In the Parc de la Villette, Tschumi explodes the program into pieces and then places the pieces on a regular grid. He then superimposes smooth curves and lines on top of this grid. Tschumi describes this process in the following way:

> One of the goals at Parc de la Villette was to pursue this investigation of the concept of structure, as expressed in the respective forms of the point grid, the coordinate axis (covered galleries) and the random curve (cinematic promenade). Superimposing these autonomous and completely logical structures meant questioning their conceptual status as ordering machines: the superimposition of three coherent structures can never result in a super coherent megastructure, but in something undecidable, something that is the opposite of a totality.

Since deconstruction is about interpretation, there is an alternative interpretation of this superimposition of a grid, lines, and curves. These bring to my mind images of Cartesian analytic geometry, a cognitive system that assumed that all things could be known in an absolute way. Superimposed grids, lines, and curves naturally fit together since the Cartesian grid provides the space within which lines and curves are defined.

Deconstruction would be better expressed through the use of fractal planning. Actually some of what Tschumi wrote about Parc de la Villette in *Architectural Design: Deconstruction in Architecture* suggests fractal images. He writes that the "works have no beginnings and no ends" also that "the project is never achieved, nor are the boundaries ever definite." Julia sets have no beginning or ending, and their boundaries are never definite. One can zoom in on a Julia set boundary forever, and there will still be more complexity to explore. Fractals in general have a beginning, but they do not have an ending. They must be generated to an infinite resolution to achieve mathematical fractal status. Tschumi also writes that "the idea of order is constantly questioned, challenged, pushed to the limit." Random fractals provide an interesting way of looking at the idea of order and scales of order and surprise.

In the spirit of the comments in the previous paragraph, here is a late entry in the Parc de la Villette competition. Rather than exploding the program onto a Euclidean grid, curdle the program onto a fractal dust. Figure 8.24 shows the process of curdling. A nine square grid with a probability of (2/3) in the first stage, (1/2) in the second stage, and (1/3) in the final stage was used.

The final fractal dust provides a challenge to the concept of order and interpretation. The curdling process produces a fractal clustering that contains a mix of order and disorder. A similar random curdling process condensed the material of the universe into the stars we see in the night sky. The night sky's clustered mix of order and disorder has provided mankind with a pattern to project interpretation onto since the beginning of time.

FIGURE 8.24 • Curdling a fractal dust for a late entry in the Parc de la Villette competition. The probabilities used were (2/3) in the first stage, (1/2) in the second stage, and (1/3) in the final stage.

FIGURE 8.25 • Fractal dust as a planning grid for a late entry in the Parc de la Villette competition. The curdle used a probability (2/3) in the first stage, (1/2) in the second stage, and (1/3) in the third stage. This is the final dust of the curdle shown in Figure 8.24.

Indigenous Design

Indigenous architecture presents complex rhythm structures to the observer. There is a fractal mix of order and surprise. Figure 8.27 shows a row of indigenous houses from Amasya, Turkey. Figures 7.18, 7.19, and 7.20 demonstrate a box counting fractal analysis of this indigenous housing. The fractal dimension of this traditional housing was approximately 1.6 across a wide range of scales from urban layout to elevation detail.

If a designer wants to produce new buildings that blend into an indigenous environment, a careful study of the indigenous buildings is the first step. The row of houses shown in Figure 8.27 has a deep structure of a base and a top that all the houses have in a fairly similar form. Superimposed on the deep structure there is a variation of house height and width and a variation of

FIGURE 8.26 • Alternative fractal dust as a planning grid for a late entry in the Park de la Villette competition. This fractal dust is from a star map around the constellation of Orion.

FIGURE 8.27 • A row of traditional houses in Amasya, Turkey.

FIGURE 8.28 • An elevation of a new midrise housing block designed by Marilyn Appleby in William Bechhoefer's graduate design studio at the University of Maryland.

window type and placement. Thus the elevations of any new building require a mix of traditional and fractal methods to achieve a pleasing result. Marilyn Appleby followed this mix in the design of the elevation shown in Figure 8.28. She provided a base and a top. Then she used music from a waltz by Johannes Brahms to provide a complex pattern of setback and window type. Figure 8.29 shows a portion of the waltz divided into halves, quarters and eighths so that a rescaled range calculation of the fractal dimension can be performed.

FIGURE 8.29 • A sequence of notes from a waltz by Johannes Brahms divided in half, in quarters, and in eighths so that the fractal dimension of the rhythm can be calculated with rescaled range analysis.

The fractal dimensions for the waltz are as follows.

$$D(14 \text{ notes to } 8 \text{ notes}) = 1.76$$
$$D(8 \text{ notes to } 4 \text{ notes}) = 1.50$$
$$D(14 \text{ notes to } 4 \text{ notes}) = 1.63$$

These fractal dimensions are very similar to the fractal dimensions that were calculated for the traditional housing shown in Figure 8.27.

Fractal rhythms should not be thought of as a magical tool that will provide interesting design. Fractal rhythms provide a method of laying down a complex rhythm where it is appropriate to have a complex rhythm.

Sea Ranch and Nantucket

It is not necessary to generate streams of numbers to apply the ideas of fractal geometry to a design situation. Frank Lloyd Wright called the process of looking to nature's deep structure *organic architecture*. An awareness of Mandelbrot's fractal geometry of nature will make it easier to see the deep structure of nature and thus to use it as a design inspiration. As an example, compare the coastal communities of Sea Ranch, California, and Nantucket, Massachusetts.

As we have seen, fractal geometry is the study of mathematical shapes that display a clustered cascade of never ending self-similarity as one observes them more closely. Nature presents itself as a cascade of fractal shapes from trees to galaxies. The way nature changes through time (weather patterns, flood levels, ocean currents) also presents itself as fractal. Music has a fractal characteristic that recreates this characteristic way our world changes through time. Mandelbrot used a coastline as his introductory example of natural fractal variation.

FIGURE 8.30 • A sketch of the condominium building at Sea Ranch, California.

This is no accident. The appeal of the coastline lies in the dramatic layering of self-similar structure from bay to cove to beach to the structure of shells discarded by the waves in crescent collections echoing the crescent wave forms flowing up the beach. Like good music, the coastline reminds us of nature's pleasant mix of order and surprise.

Sea Ranch, California, and Nantucket, Massachusetts, provide contrasting fractal characteristics in their coastlines and in their built forms. The coastline at Sea Ranch has a rough edge at both a large scale and a small scale as observed by a person walking along the coastline. The design guideline documents for Sea Ranch call for complex shapes (Bocke et al., 1985). Many of the houses display this complexity. The best example is the condominium building designed by Moore, Lyndon, Turnbull, Whitaker (MLTW) in the early sixties, one of the original buildings at Sea Ranch. From a distance the building looks like a large rock outcropping. The rocks below and the building above have similar form characteristics. The Sea Ranch condominium has the gross texture of the natural spot it is located in.

The coastline of Nantucket is relatively smooth until the scale of the texture of the waves washing up on the beach and the result of wave action on dunes and bluffs are encountered. At this small scale the coastline has a fractal complexity similar to Sea Ranch. The design guidelines for Nantucket, based on the indigenous buildings of the island, call for simple, basic shapes with interesting rhythms provided by window and door size and spacing (Lang, 1978). This form is very appropriate to a coastline that is smooth at the large scale and complex at the small scale.

Both Sea Ranch and Nantucket call for clustering in their design guidelines. Nantucket formed in clusters around the original towns on the island. Sea Ranch was deliberately designed as clusters of houses in order to preserve the meadows and the coastline for all to use.

The rhythms presented by the trees in a forest or the wash of the waves along a beach provide good examples of nature's fractal character. They are

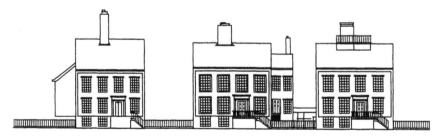

FIGURE 8.31 • A drawing of three houses along Main Street in Nantucket, Massachusetts. Reproduced with permission from *Building with Nantucket in Mind,* Christopher Lang, Nantucket Historic District Commission, 1978.

Geology of Nantucket

Geology of Nantucket

- ▦ Outwash plain
- ▦ Fosse
- ▦ Moraine
- ▢ Post-glacial deposits

Geology of Nantucket

Topographic enclosure of the landscape

- ▦ Flat open plains
- ▧ Glacial valleys
- ▦ Elevated edges and bowls
- ▦ Hummocky moraine

Topographic categories on the island.

FIGURE 8.32 • A drawing of the island of Nantucket, Massachusetts. Reproduced with permission from *Building with Nantucket in Mind,* Christopher Lang, Nantucket Historic District Commission, 1978.

FIGURE 8.33 • Traditional residential zoning ignores natural features. Reproduced with permission from *Building with Nantucket in Mind*, Christopher Lang.

pleasant because they have an appropriate mix of order and surprise. A coastline seen with Euclidean awareness is chaos. A coastline seen with fractal awareness is an interrelated cascade of self similar-clusters of rhythmic structure, providing a rich source of design concepts.

FIGURE 8.34 • Clustered zoning can be set up to be in sympathy with natural features. Reproduced with permission from *Building with Nantucket in Mind*, Christopher Lang, Nantucket Historic District Commission, 1978.

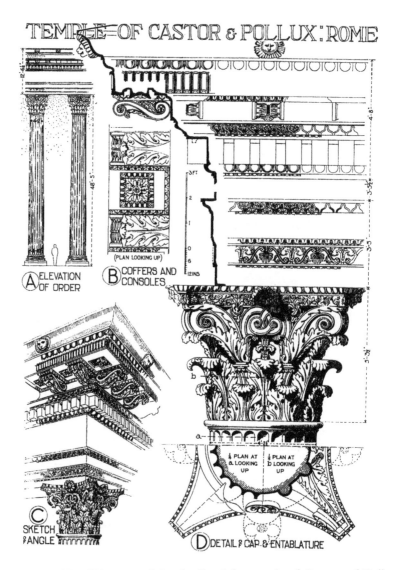

FIGURE 8.35 • Diagrams of the details of the temple of Castor and Pollux in Rome. Reproduced with permission from The British Architectural Library, RIBA, London.

Further Study

Classical architecture provided a wealth of detail to interest the eye. Figure 8.35 is a collection of drawings of classical detail from a Roman temple. High tech and deconstructivist architecture can provide a modern equivalent of the cascade of interesting detail that classical architecture provided. Figure 8.36 is a longitudinal and transverse section through a penthouse addition to an apartment building in Vienna, by Coop Himmelblau. A measure of the fractal cascade displayed in classical architecture could be used as a design guide to producing a similar textural depth of field with modern materials and methods. Reproduce the quality of the visual experience without copying the actual forms.

FIGURE 8.36 • Longitudinal and transverse sections through a penthouse addition by Coop Himmelblau. Reproduced with permission from Coop Himmelblau.

FIGURE 8.37 • A residential project by Lucien Kroll. Reproduced with permission from *The Architecture of Complexity*, Lucien Kroll; The MIT Press, 1986.

Fractals are about the complexity of boundaries whether of a Julia set or the coast of Britain. The work of Lucien Kroll explores a complex boundary between architect, user designed space, and industrial design. Figure 8.37 is one of his wonderfully diverse residential projects. It shows the progression of texture he incorporates in his projects.

Archetypes in Architecture by Thomas Thiis-Evensen provides a beginning study toward the classification of basic architectural forms according to their emotive architectural effect. If these sets could be ordered in some way, fractal layouts based on them could have considerable emotive power.

Design is very much about control over contrast. Fractal methods provide an additional tool that can be used. Alvar Aalto's church center in Riola displays a sequence of contrasts; the rectangular form against the curvilinear form; the cascade of curved forms of the roof against the cascade of rectangular retaining walls; the cascade of the texture of the stone set against the cascade of the roof and retaining walls. Use the fractal grids shown in Figure 8.16 or 8.18 as a guide for a graphic design layout. Try a fractal dust as a layout guide.

William Mitchell, in *The Logic of Architecture*, demonstrates shape grammars that are a set of rules that generate architectural form. Some of the rule systems are recursive. Remember the recursive rules that generated the basic fractals in Chapter 2 and the Julia sets in Chapter 4. Przemyslaw Prusinkiewicz and Aristid Lindenmayer in *The Algorithmic Beauty of Plants*, also set up recursive rule systems. Their systems are based on plant forms rather than architectural forms. They go one step further by including chance in the rule systems. Including a random component means that every lilac bush that is generated is slightly different.

FIGURE 8.38 • A theatrical set designed in 1931, by Iakov Chernikhov.

The Constructivists created compositions that span scale. A central feature of fractals is that they present interest across a wide range of scale. The Constructivists also broke away from classical ideas of balanced and hierarchical composition which is a move toward including randomness into the process. Figure 8.38 is a theatrical set from 1931, by Iakov Chernikhov.

References

Arnheim, Rudolf. 1977. *The Dynamics of Architectural Form.* Berkeley: University of California Press.

Baker, Geoffrey. 1989. *Le Corbusier: an Analysis of Form.* Hong Kong: Van Nostrand Reinhold.

Barnsley, Michael. 1988. *Fractals Everywhere.* Boston: Academic Press.

Barnsley, Michael. 1992. *The Desktop Fractal Design System.* Boston: Academic Press.

Barnsley, M. F., R. L. Devaney, B. B. Mandelbrot, H. O. Peitgen, D. Saupe, and R. F. Voss. 1988. *The Science of Fractal Images.* New York: Springer-Verlag.

Bayley, S., P. Garner, and D. Sudjic. 1986. *Twentieth Century Style and Design.* New York: Van Nostrand Reinhold.

Bechhoefer, William, and Carl Bovill. 1994. "Fractal Analysis of Traditional Housing in Amasya, Turkey." *Proceedings of the Fourth Conference of the International Association for the Study of Traditional Environments.* Berkeley: International Association for the Study of Traditional Environments.

Becker, Karl, and Michael Dorfler. 1989. *Dynamical Systems and Fractals*. Cambridge: Cambridge University Press.

Bocke, A., J. Esherick, L. Halprin, R. Johnson, D. MacDonald, C. Moore, H. Sasaki, and W. Turnbull. 1985. *Process for the Future of Sea Ranch*. Sea Ranch: The Sea Ranch Association.

Borras, Maria. 1967. *Arquitectura Finlandesa*. Barcelona: Ediciones Poligrafa.

Bouman, Ole, and Roemer van Toorn. 1994. *The Invisible in Architecture*. London: Academic Group LTD.

Briggs, John, and F. David Peat. 1989. *The Turbulent Mirror*. New York: Harper and Row Publishers.

Capitman, B., M. Kinerk, and D. Wilhelm. 1994. *Rediscovering Art Deco U.S.A.* New York: Penguin Books.

Dyson, Freeman. 1978. "Characterizing Irregularity." Science, May 12, 1978. American Association for the Advancement of Science.

Feder, Jens. 1989. *Fractals*. New York: Plenum Press.

Fletcher, Banister. 1975. *A History of Architecture*. New York: Charles Scribner's Sons.

Gardner, Martin. 1978. "Mathematical Games, White and Brown Music, Fractal Curves and One-over-f Fluctuations." Scientific American, April 1978. New York: Scientific American.

Glick, James. 1987. *Chaos*. New York: Viking Penguin.

Helms, Roland. 1980. *Illumination Engineering for Energy Efficient Luminous Environments*. Englewood Cliffs, NJ: Prentice-Hall.

Hoffmann, Donald. 1986. *Frank Lloyd Wright, Architecture and Nature*. New York: Dover Publications.

Hoffmann, Donald. 1984. *Frank Lloyd Wright's Robie House*. New York: Dover Publications.

Johnson, Philip, and Mark Wigley. 1988. *Deconstructivist Architecture*. New York: The Museum of Modern Art.

Jones, Jesse. 1993. *Fractals for the Macintosh*. Corte Madera, CA: Waite Group Press.

Kroll, Lucien. 1986. *The Architecture of Complexity*. London: B.T. Batsford Ltd.

Lang, Christopher. 1978. *Building with Nantucket in Mind.* Nantucket, Massachusetts: Nantucket Historic District Commission.

Lee, D. L., and Y. Cohen. 1992. *Fractal Attraction, A Fractal Design System for the Macintosh.* Boston: Academic Press.

Mandelbrot, Benoit. 1983. *The Fractal Geometry of Nature.* New York: W. F. Freeman and Company.

Mitchell, William. 1990. *The Logic of Architecture.* Cambridge: The MIT Press.

Peitgen, H. O., H. Jurgens, and D. Saupe. 1992. *Chaos and Fractals.* New York: Springer-Verlag.

Prusinkiewicz, Przemyslaw, and Aristid Lindenmayer. 1990. *The Algorithmic Beauty of Plants.* New York: Springer-Verlag.

Rucker, Rudy. 1987. *Mind Tools, The Five Levels of Mathematical Reality.* Boston: Houghton Mifflin Company.

Russell, John. 1981. *The Meanings of Modern Art.* New York: The Museum of Modern Art and Harper and Row Publishers.

Schildt, Goran. 1994. *Alvar Aalto, The Complete Catalogue of Architecture, Design, and Art.* New York: Rizzoli.

Sudjic, Deyan. 1994. *Richard Rogers Bauten und Projekte.* Berlin: Ernst and Sohn.

Thiis-Evensen, Thomas. 1987. *Archetypes in Architecture.* Oslo: Norwegian University Press.

Tschumi, Bernard. 1988. "Parc de la Villette Paris." *Architectural Design, Deconstruction in Architecture.* New York: St. Martins Press.

Van Der Laan, Dom H. 1983. *Architectonic Space.* Leiden, The Netherlands: E. J. Brill.

Weyl, Hermann. 1952. *Symmetry.* Princeton: Princeton University Press.

Winograd, Terry, and Fernando Flores. 1986. *Understanding Computers and Cognition.* Reading, Massachusetts: Addison-Wesley Publishing Company.

Wright, Frank Lloyd. 1955. *An American Architecture.* New York: Bramhall House.

Index

Printed by Printforce, the Netherlands